"Is the human race condemned to destroy itself with its own weapons of mass destruction? Kazuaki Tanahashi's persuasive answer is no, but to go from a death-driven society to a society that protects life requires reenvisioning the future so that we can learn to live peacefully in the present moment. Using stories, poems, and his own art, Tanahashi's *Painting Peace* contributes to that conversion."

—Jim Forest, author of *The Root of War Is Fear:*
Thomas Merton's Advice to Peacemakers

"This book is world-treasure. Its clear and elegant prose welcomes the reader into the most remarkable life of artist, Zen teacher, and peace and anti-nuclear activist, Kazuaki Tanahashi. The true-life stories are fascinating and instructive, showing how creativity emerges at the intersection of the personal and the political, the historical and the timeless. Each short chapter is a gift of beauty, wisdom, and compassion, and all in service of a sustainable and flourishing humanity and the wider Earth community."

—Sean Kelly, author of *Coming Home: The Birth*
and Transformation of the Planetary Era

"Inspiring, fascinating, tenacious, and creative, these stories from Kaz's life as an artist, scholar, and activist offer the reader so many ways to enter the sphere of compassionate social responsibility. It's as if Kaz is sitting with the reader, coaching us to experience the potential and joy of creative problem-solving in the world of peace and environmental activism. There are brushes built, panels convened, symphonies composed, songs and poems written. Reading this is like taking a long—a lifelong—pilgrimage with a wise, compassionate man, an artist who drinks in the joys and sorrows of the world."

—Roshi Pat Enkyo O'Hara, author of *Most*
Intimate: A Zen Approach to Life's Challenges

PAINTING PEACE

Art in a Time of Global Crisis

KAZUAKI TANAHASHI

SHAMBHALA
Boulder 2018

Shambhala Publications, Inc.

4720 Walnut Street

Boulder, Colorado 80301

www.shambhala.com

© 2018 by Kazuaki Tanahashi

9 8 7 6 5 4 3 2 1

First Edition

Printed in the United States of America

♾ This edition is printed on acid-free paper that meets the American
National Standards Institute Z39.48 Standard.

♻ Shambhala makes every effort to print on recycled paper. For more
information please visit www.shambhala.com.

Distributed in the United States by Penguin Random House LLC and in
Canada by Random House of Canada Ltd

Designed by Liz Quan

LIBRARY OF CONGRESS CATALOGING-IN-PUBLICATION DATA

Names: Tanahashi, Kazuaki, 1933– author.

Title: Painting peace: art in a time of global crisis / Kazuaki Tanahashi.

Description: First edition. | Boulder: Shambhala, [2018]

Identifiers: LCCN 2017031907 | ISBN 9781611805437 (pbk.: alk. paper)

Subjects: LCSH: Tanahashi, Kazuaki, 1933–.—Themes, motives. |
Art and social action.

Classification: LCC NX584.Z9 T3882 2018 | DDC 701/.03—dc23

LC record available at https://lccn.loc.gov/2017031907

TO MAYUMI ODA

my dear coworker for life on earth

Artists need the world;
without the world
there can be no art, no artist.

CONTENTS

LIST OF ILLUSTRATIONS

Page 65 Booklet, *Japan's Plutonium: A Major Threat to the Planet.* Cover art by Mayumi Oda and KT. Published by Plutonium Free Future, 1992.

Page 67 Poster, *Who will guard this plutonium?* Acrylic on paper, 23½" × 29½", 1992.

Page 68 Print, *Journey of the* Akatsuki Maru. Print, 20" × 26". Mario Uribe, calligraphy by KT, 1992.

Page 71 Poster, *No nukes!* 17½" × 24", 2013.

Page 75 Creating the *Circle of All Nations.* Photo by Kazu Yanagi. Organized by American School of Japanese Arts and artistic director Mario Uribe. United Nations Plaza, San Francisco, 1995.

Page 75 Installing the *Circle of All Nations.* Five panels, 23' × 28' in total, plus two horizontal banners, 4' × 23' each. Photo by Kazu Yanagi. Organized by American School of Japanese Arts and artistic director Mario Uribe; calligraphic director, Georgianna Greenwood. War Memorial and Performing Arts Center, San Francisco, 1995.

Page 76 The *Circle of All Nations,* installed. Photo by Kazu Yanagi, 1995.

Page 87 Poster, *Grieving of Humanity.* 23½" × 29½". Birkenau, Poland, 1997.

Page 95 Painting, *Nanjing Lamentation.* Acrylic on canvas, 30" × 36". Exhibited at the Remembering Nanjing Tragedy Conference, Nanjing Normal University, Nanjing, China, 2007.

Page 96 Painting, *Rapes and Devastations.* Acrylic on canvas, 30" × 36". Exhibited at the Remembering Nanjing Tragedy Conference, Nanjing Normal University, Nanjing, China, 2007.

Page 99 Painting, *Atonement: One Hundred Million Japanese.* Acrylic on canvas, 30" × 36". Exhibited at the Remembering Nanjing Tragedy Conference, Nanjing Normal University, Nanjing, China, 2007.

Page 103 Painting, *Manchuria Live Human Experiments.* Acrylic on canvas, 30" × 36". Exhibited at the Remembering Nanjing Tragedy Conference, Nanjing Normal University, Nanjing, China, 2007.

Page 104 Painting, *Life's Dreams Are Lost.* Acrylic on canvas, 30" × 36". Exhibited at the Remembering Nanjing Tragedy Conference, Nanjing Normal University, Nanjing, China, 2007.

Page 121 Creating *Circle of Peace.* By members of the Interfaith Pilgrimage of Peace, monastery of Deir Mar Musa el-Habashi, Syria, 2002.

PREFACE AND ACKNOWLEDGMENTS

How do we bring about a large-scale social transformation? How do we reverse the direction of the human race toward a collective suicide? How do we respond to systematic violence nonviolently? How do we help nations to effectively dismantle and abolish their military forces?

A vision of the future is drawn with our imagination, which may be seen as a brush that depicts dreams, hopes, and predictions for forthcoming as well as faraway days. You have a brush, and I have another. In fact, every one of us has a formless brush with boundless capacity.

What you draw may be different from what I draw in color and shape, or in theme and tone. And yet, there must be similarities. It is humbling to realize that the "brush" that leads my thoughts and actions for social transformation is one of the millions and billions of "brushes" at work in the world.

One thing for sure is that peace in the world starts with peace of mind in each one of us, and social transformation is based on the awakening of each one of us. To awaken is to realize the infinite value of each moment of your own life as well as the life of other beings, then to continue to act accordingly.

In my mind, this book is "A Letter to a Young Artist." (We all are artists when we work with imagination. And regardless of our ages, we can be *young* artists who have infinite possibilities.) I am presenting stories and reflections, woven together with poems for songs (often with refrains), music, and visual art, as material that might help you to develop your own ideas about the use of art for peace and environmental work.

Part One of this book, "A Brush with Our Time," presents rough sketches that create a profile of the twentieth century through anecdotes about some people close to my heart. This part also includes observations on my growing creative process as an artist.

Part Two, "Engaged in Our Time," represents some of my work and thoughts between the 1980s and early 2010s, beginning with my work to reverse the nuclear arms race.

Part Three, "Principles of Engagement," contains theoretical understandings and suggestions about individual and social action, based on my own experience.

Part Four, "Shaping Our Time," reflects positive visions of the world, including those for an ultra-long-term future.

This book is related to *Painting Peace,* a 2013 film by Babeth Van Loo. There is a link to her film as well as some short films that represent some of my peace work in the "Video and Audio Sources" section at the back of the book.

Three of my poems in this book are dedicated to my wife, Linda, daughter, Karuna, and son, Ko, respectively. And there are links in the "Video and Audio Sources" section to some songs based on poems in this book.

My initial inspiration on peace work owes to O'Sensei Morihei Ueshiba, my father, Rev. Nobumoto Shigeo Tanahashi, Thich Nhat Hanh, and the thirteenth-century Japanese Zen master Dogen. Numerous friends have guided me on peace and environmental work. In particular, my deep appreciations go to President Rodrigo Carazo, Wouter Schopman, Shunryu Suzuki Roshi, Robert Aitken Roshi, Gary Snyder, Dr. Daniel Ellsberg, Rev. David Chadwick, Edie Hartshorne, Liz Uribe, Bob Brockob, Georgianna Greenwood, Haruyoshi Ito Sensei, Prof. Ewan Clayton, Shaykh Elias Amidon, Fr. Paolo Dall'Oglio, Dr. Michael Ashkenazi, Prof. Zhang Liangho, Prof. Yang Xuaming, Dr. Haruhiko Murakawa, Prof. Kuniko Muramoto, Iris Chang, Prof. Shudo Higashinakano, Jun'yu Kuroda Roshi, Joan Halifax Roshi, Pat Enkyo O'Hara Roshi, Sherry Shinge Chayat Roshi, Jan Chozen Bays Roshi, Hogen Bays Roshi, Bernie Glassman Roshi, Richard Baker Roshi, Rev. Genzan Quenell, Dr. Friederike Boissevain, Dr. Harald Schöklmann, Dr. Joanna Macy, Fran Peavy, Kiyoshi Miyata, Mayumi Oda, Fusako di Angelis, Yoko

Nakano, Prof. Tamio Nakano, Dr. Jinzaburo Takagi, Prof. Julian Gresser, Claire Greensfelder, Dennis Rivers, Nancy Bardakke, Kinji Muro, Dr. David Krieger, Rev. Alan Senauke, Dieter Erhard, Sunny Shender, Fr. John Dear, Rev. James Lawson, David Hartsough, Dr. Sean Kelly, Dr. Gene Sharp, Dr. Mariah J. Stephan, Prof. Erica Chenoweth, Dr. Mark Gonnerman, Christine Haggarty, Minette Mangahas, Grainne Carr, Brendan Dowling Sensei, Rev. Yoshimoto Tanahashi, and Ko Tanahashi.

The works of filmmakers Babeth Van Loo, Ashley James, Martijn Robert, Bennie von Bresius, JR Sheetz, and Karuna Tanahashi have helped elucidate my peace work a great deal. I offer my thanks to Dr. Robert Kyr, Rev. Luc De Winter, Betsy Rose, and many others who have set my peace poems to music. Thanks to Judith-Kate Friedman for creating the *Imagining Peace* CD. Thanks to Dr. Doreen Rao for inspiring me to write poems for songs. And thanks to my long-term artistic collaborator, Mario Uribe.

My gratitude goes to Dr. Susan O'Leary, Peter Levitt, Roberta Werdinger, Dr. Suzanne Moss, and Dr. Linda Hess for offering excellent editorial advice. I would also like to thank Barbara Bonfigli, Marilynn Preston, Diane Abt, and Josh Bartok for their advice. Thanks to Kazu Yanagi, Iwona Michalczewska, and Mitsue Nagase for their photographic work.

I also have had the pleasure of working with Marion Hunt, Assistant Secretary-General Robert Muller, Manec van der Lugt, Dr. Bart van der Lugt, Kisshomaru Ueshiba Sensei, Dian Woodner, Natalie Goldberg, Kathleen Sweeney, Thomas Ingmire, Tom Driscoll, Michael Podgorschek, Christine Griessler, Dr. Erich Griessler, Dr. Roger Keys, Liza Matthews, Dr. Steven Heine, Dr. Taigen Dan Leighton, Prof. Jaswant Guzder, Prof. Michael Nagler, Ivone Forman, Prof. Robert K. C. Forman, Dr. Jon Kabat-Zinn, Ursula Stricker, Manfred Lehmann, Marko Marffi Sensei, Catherine Margerin, Catherine Allport, Bodhi Keven Setcho, Evelie Delfino Sáles Posch, Nicole Milner, PhoeBe Anne Sorgen, Shira Kammen, Masakazu Masukawa, Patricia Gidney, Dhalia Kamesar, Jack Kamesar, Rev. Heinz-Jürgen Metzger, Christoph Hatlapa Roshi, Dr. Amy Mindell, Dr. Arnold Mindell, Nora Akino, Eri Suzuki, Yuka Saito, James Butler, Soichi Nakamura Roshi, Mahant Veer Bhadra Mishra, Michael Phillips, Rob Lee, Marc Lesser, Suzuko Omura, Yasuko Tanahashi, Shigeyoshi Tanahashi, Kiyo Ito, Frank Ostaseski, Paul Maurer,

Carole Rae Watanabe, Elisabeth van Deurzen, Aspy Khanbatta, Reb Tenshin Anderson Roshi, Sojun Mel Weitsman Roshi, Dairyu Michael Wenger Roshi, Lowell Brook, David Brown, Joshua Arone, David Zapf, Nick Weiss, Paulette Crisman, Dr. Steve Crisman, Dr. Philip Schechter, Dr. Angela Jannsen, Dr. Norbert Jannsen, Prof. Rabia Roberts, Urlike Serak Sensei, Thorsten Schoo Sensei, Brendon Dowling Sensei, Terry Dobson Sensei, Susan Perry Sensei, Prof. Ron Rubin, Roy Maurer Jr., Rev. Chieko Tanahashi, Rev. Akari Tanahashi, Dr. Larry Dossey, Robert Wolfe, Prof. Abelardo Brenes, Dr. Walter Truett Anderson, Prof. Alfred W. Kaszniak, Dr. Neil D. Theise, Prof. Piet Hut, and Aikido Doshu Moriteru Ueshiba Sensei. Thanks to Victoria Shoemaker for representing me.

It is always an honor to work with a number of friends at Shambhala Publications, including Nikko Odiseos and Hazel Bercholz. Thanks also to assistant editor Audra Figgins. Dave O'Neal guided me throughout the production of the book.

Deep, deep bows!

KAZUAKI TANAHASHI

PART ONE

A Brush with Our Time

.

Pine Needle

A pine needle
in an ocean of trees.
 Timeless serenity
 of this very moment.

A pine needle
lying in the stone garden.
 Timeless serenity
 of this very moment.

A pine needle
flying in a stormy wind.
 Timeless serenity
 of this very moment.

Years before Pearl Harbor

My brother and I found a coin in an alley in a residential area of Tokyo around 1939. Shigeyoshi was four or five, and I was one year older. We went to the police box nearby and reported that we had found a coin. To us a police officer was the ultimate authority—someone we kids ought to fear, and someone to whom we must never be brought for lying or stealing.

I still remember vividly how impressed the policeman was when we told him our father's occupation—a staff officer in the Imperial Military Headquarters. I started suspecting at that moment that my father might be doing something important. Later I learned that he was one of several officers in charge of plans to equip the entire army.

In December 1940, my mother, brother, and I, along with other family and friends, were at Shimbashi Station in Tokyo. Morihei Ueshiba, founder of the martial art aikido, was there wearing his *hakama* and black kimono with a cane in his hand. We had all come to see my father off on a trip to Europe. In his army uniform, Major Shigeo Tanahashi stood at the end of the caboose and turned his stretched arm in a full circle over and over again while the westbound express accelerated. I had no idea at that time that the increasing distance between Morihei and my father was tearing apart a chance for Japan and the United States to prevent Pearl Harbor.

In the memoir Shigeo wrote in 1955, he revealed one of Japan's secret efforts to avoid a war in the Pacific. By 1938 he had learned in detail about Japan's colonial expansion policies and about US military and industrial supremacy over Japan. In the summer of that year, a message from the Shinto deity in whom he had faith flashed across his mind: "Japan and the United States are very likely to go to war. Japan will lose and be confined to its small islands."

Shigeo became very worried and restless. He went to see Morihei, with whom he had been studying closely since 1932, and talked to the master about his concern. The master said, "I agree with you, Tanahashi-san. We must try as hard as possible to avoid the war. I would very much like you to work on it. You will have all my support."

As a war planner, it was part of Shigeo's job to analyze the strength of the armed forces of Japan and its neighbors, and to make recommendations for military policy. He got permission from his superior officer to organize a secret plan, involving civilians as well as the Japanese military establishment, to prevent a war in the Pacific. He went to see cabinet members, including Prime Minister Prince Konoe, advisers to the emperor, and the emperor's brother Prince Chichibu, to present his plan.

In prewar Japan, however, any civilian or soldier (other than war planners) who openly mentioned another nation's military superiority or the idea of preventing war would be arrested, tortured, and perhaps killed. Shigeo had to keep the involvement of Morihei in utmost secrecy to protect the master's life. Consultation with him usually took place after Shigeo joined the evening training at aikido's main dojo. Other main players in the peace campaign included Shumei Okawa, a well-known nationalist thinker, and millionaire Suekichi Nishikawa. The US collaborators included Harry Chandler, publisher of the *Los Angeles Times*.

The embargo by the United States, Great Britain, and the Netherlands, enforced in reaction to Japan's occupation of part of Indochina, was choking Japan. The extreme shortage of petroleum was pushing Japan toward taking military action against the United States and others. Diplomatic negotiations between the Allies and Japan were stalled. Shigeo and his colleagues came up with a plan to establish a binational corporation in the United States, with special permission from the State Department to export aviation-quality fuel oil to Japan as a sign that the United States wished to reduce tensions. The estimated cost of the program was $300,000. The project got approval from all involved parties, and Shigeo raised an initial $30,000 from the secret fund of Japan's General Staff Office in late 1939 to begin establishing the Pan Pacific Trading and Navigation Company in Nevada. (This sum was more than a month's secret service budget for the entire General Staff Office.) The

Japanese government agreed to pay half of the $300,000 in the following year as soon as the US government paid the other half, for full operation of the corporation.

But the military leaders of Japan saw any effort for peace as a sign of weakness and decided to eliminate all such negotiations. Shigeo was ordered to go to Europe to study the weapons systems of Hitler and Mussolini. When Morihei heard about Shigeo's transfer, he saw Japan's inevitable path to war in the Pacific and to defeat. Tears in his eyes, the master held Shigeo's hands and said, "Tanahashi-san, our peace work is crushed now. Many, many people will suffer incredibly in the coming war. As a soldier you will have to fight. Always remember to take care of yourself. But let's trust that there will be another opportunity for us to work for peace."

One year after that day at Shimbashi Station came the surprise attack on Pearl Harbor, and four and a half years later, Hiroshima and Nagasaki. Millions of lives were lost in that tragic war.

After the war, Shigeo became a Shinto priest. He started a group called Heiwa Kyokai (Peace Church) and taught many people a spiritual path for peace. His favorite quotation was from the *Art of War* by Sunzi, a Chinese strategist of the fourth century B.C.E.: "If you win one hundred battles out of one hundred, it is not good enough. Winning a war without fighting is supreme."

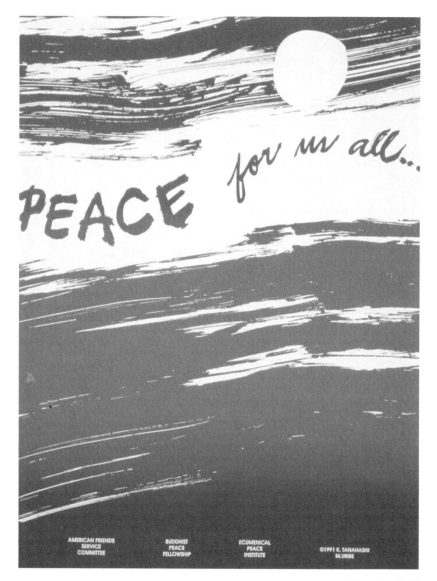

Peace for us all

The Zen of Ending War

During World War II, the Zen monk Soen Nakagawa was living at the Ryutaku Monastery on the rural hill of Mishima, near Mount Fuji, Japan. He wrote this subtly antiwar haiku:

> News of a victorious battle
> I just shuffle along in the mud
> at this spring temple.

After US forces captured a few Pacific islands in hellish battles, their bombers started to devastate Japanese cities. Monk Soen replaced one word of the poem, *senka*, with another word which sounds the same but is spelled differently:

> News of a disastrous battle
> I just shuffle along in the mud
> at this spring temple.

Months after Japan's surrender in August, 1945, he wrote:

> City of ashes
> Fuji soars serene
> New Year's first light.

Surprisingly enough, during the 1946 *rohatsu sesshin* (the December meditation intensive commemorating the Buddha's enlightenment), an American was already participating at the monastery. Soen wrote:

> Middle day of rohatsu
> sitting with us
> a G.I.

In 1951, after the retirement of his eighty-six-year-old teacher Gempo Yama-moto, who had been nearly blind since his youth, but was highly regarded for his profound insight, monk Soen assumed abbotship of Ryutaku-ji. It is a small but important monastery, founded by the eighteenth-century master Hakuin who revitalized the Rinzai School of Zen, and who created the koan, "What is the sound of one hand clapping?" Some Westerners were attracted to this training center, where the abbot spoke English.

In the same year, Soen Roshi went to Yokohama to see off Robert Aitken, who would later become one of the first *roshis* (Zen masters) in the Western world. At that time Bob was going back to the United States after a half year's stay in the monks' hall. Soen wrote:

> One hand
> waving endlessly
> autumn ocean.

Although I did not have the opportunity to meet this legendary Zen master, I adored his poems. This led me to collaborate with his dharma descendant, Roko Sherry Chayat, the teacher at the Zen Center of Syracuse, in compiling a book on the Zen path of Soen Nakagawa titled *Endless Vow*. (As Shinge Roshi, she is now abbot of the Zen Center and the Dai Bosatsu Zendo in upstate New York.) During our work in 1995, I learned a story about how Soen's teacher, Gempo Roshi, had contributed significantly to ending the war. I remembered vaguely having read about it in a Japanese magazine a long time before.

It felt like a coincidence that I was reminded, exactly half a century later, of Gempo Roshi's influence on the fate of the nation, as well as of the world. I had always been troubled by how little Japanese Buddhists had done to oppose imperialism, colonialism, racism, sexism, militarism, and war, while Japan was brutally expanding its empire in Asia and the Pacific. So it was important for me to know that someone had done something.

In 1945, Japan was in an impossible situation, which was clear even to an eleven-year-old boy like myself. On the one hand, we had been made to be-lieve, by a massive brainwashing education, that Japan was a divine nation; that it had never lost and would never lose in war. On the other hand, despite all the radio propaganda from military headquarters, there was no question

that Japan kept losing important battles on land and sea. US bombers were cruising unchallenged at high altitudes, burning city after city.

Even in primary school, kids were all taught that surrender was utterly disgraceful and should never be considered a choice. Since there was no hope for Japan to win the war, and surrender was out of the question, the fate for us civilians was either to be killed by the enemy or to kill ourselves by jumping off a cliff or drowning ourselves. The government was propagating the poetic but horrifying message *ichioku gyokusai*, which meant "one hundred million people crushed like jewels." The entire nation was taking a fanatic dive toward collective suicide.

Merely mentioning to friends or family members the potential of the nation's surrender was regarded as an act of treason. In this state of terror, the Zen monk Gempo was one of the few people who had the wisdom to see the reality of the nation's situation and the courage to risk his life by speaking truthfully.

Several people speak of the incident in a book called *Kaiso: Yamamoto Gempo* (Memories of Gempo Yamamoto), edited by Benkichi Tamaoki. In April 1945, General Kantaro Suzuki was offered the prime ministership to replace General Hideki Tojo, who had started, conducted, and ultimately lost the war as prime minister. At a secret meeting in Tokyo with Gempo Roshi, General Suzuki asked for his advice.

Without hesitation, Roshi encouraged Suzuki to assume the office and lead Japan to surrender as soon as possible. A week later Suzuki became the prime minister.

Early on the morning of August 12, a messenger from Suzuki informed Roshi of Japan's decision to surrender unconditionally. Roshi wrote back: "Your true service is starting now. You must endure the unendurable, bearing the unbearable."

At noon on August 15, Emperor Hirohito made his very first radio broadcast and read his edict, ordering an immediate ceasefire. The most quoted line from this historic announcement remains the paradoxical Zen phrase: "We shall seek peace for myriad generations, enduring the unendurable, bearing the unbearable."

Wataru Narahashi, formerly a key member of the Constitution Drafting Committee, also testifies about his experience in 1945 in this book. Seeing

Narahashi arrive and enter the room at the hot-springs inn to meet him, Gempo said, "Does your visit concern the status of the emperor?" Narashashi was shocked, as this was precisely the secret issue he had been sent to discuss. He said, "You are right, Roshi. We need your advice."

The drafting committee for Japan's new constitution had become polarized and was unable to reach agreement on whether imperial rule should be continued or eliminated. Some political leaders believed that elimination of imperial rule would upset millions of people and be a cause of nationwide riots. People had been conditioned to dedicate their lives to the emperor. Others, including those who were occupying Japan, did not want continuation of the imperial system that had led Japan to conquer most of Asia. The drafting committee was under great time pressure, as the Soviet Union was demanding that Japan be divided and the northern island of Hokkaido be occupied by the Soviets. They needed to propose a draft quickly before the Soviets threatened to move forces into Hokkaido.

Responding to Narahashi's inquiry, Gempo said nonchalantly, "If the emperor maintains political power, it is bound to be misused. Instead, the emperor should be a symbol, shining high in the sky—like the sun." Narahashi thought it was a brilliant idea and brought it to his colleagues and the US liaison officers in the occupation forces. Everyone supported this idea, which became one of the central concepts of the new constitution: "The emperor is the symbol of the nation of Japan."

Like millions of other people in Japan, I had been familiar with this opening line of Article One of the constitution. But like most others, I had failed to see in this line a monk's lifelong meditation. He just kept deepening his insight for no particular purposes, but when required, he could give guidance that helped shape the society.

Courage

True courage is composure
 in all situations

True courage is being thoughtful
 in all situations

True courage is loving compassion
 in all situations

True courage is being nonviolent
 in all situations

True courage is maintaining peace
 in all situations

A Small Circle

What if a super-warrior had a clumsy student? After Japan's surrender, everyone was confused, humiliated, and poor. Japan had been occupied by the Allied Forces. All the martial arts had been prohibited. An old man was growing rice and yams in a country village and was teaching an underground martial-art class in a small dojo surrounded by young pine trees. He had about five kids at the nightly training.

I was part of that group, studying with Morihei Ueshiba, the founder of aikido. (We were a bunch of boys; no girls were practicing in the class—perhaps the only class of aikido in Japan, and that means in the world, at that time. My brother Shigeyoshi and I were in the first postwar group of learners, as my father had been previously a disciple of Ueshiba's.)

A thirteen-year-old boy who loved the dense smell of Western philosophy, I was not at all physical; every movement I made was destined to be chaotic. While my fellow students were beautifully thrown down by the master, I would cling to his arm so he had to shake me off.

After one of us was thrown down by Morihei and rolled on the wooden floor, he would kneel and keep him down with a little finger, making no effort whatsoever. Sometimes he sat on his knees and let all of us try to push him down; he was relaxed with a smile, and it was impossible to move him an inch, however hard we tried. I had no idea how this short man with a white beard could do such a miraculous thing, and I had no clue as to how to get the secret of the art.

Our training with Grand Master, as we called him, was mostly a repetition of the same routine. First, we would choose a partner and sit on our knees facing each other. One of us would grab the other's wrists and press hard. The other would fully open the fingers with palms up and turn his

wrists while twisting them forward and up in a screwlike motion, eventually throwing the partner down onto one side. This is called "breath movement." In my understanding this is how we learn to exert force by incorporating breath energy with a body movement. *Aikido* means "unifying breath way."

Then, the master would call on one of us and show us a movement. He would ask the student to attack with a "hand sword" (using a straight hand with fingers together as a "cutting weapon"). He might signal us to attack him with a spearlike thrust with the fist, or with a grab to his wrist or onto part of his washed-out training clothes. The master would move in a circular motion, divert the student's forthright force, utilize the momentum of his movement, and throw him down.

Then we would work in pairs imitating his movement. In aikido's bare-hand training, there are only a few basic patterns, but they can be executed with infinite variety. We learned them over and over again.

Ueshiba's basic teaching was nonresistance. We were not supposed to resist any oncoming force. He would hate it when he saw us struggle or compete in our strength. We were taught to fully collaborate with the partner's movement.

He also talked about nonviolence and strictly cautioned us not to use the art for fighting. For him aikido was not any kind of sport; we had no matches or competitions.

Ever since his youth, he had participated in innumerable matches and built up his reputation as an invincible warrior. Then, in 1925, he had an enlightenment experience, realizing that the source of the art of warriorship is love. Soon he created aikido based on that principle. But at the time of the expanding empire, many people went to study with him trying to acquire the art of winning battles and of conquest. Thus, before and during World War II, aikido was a synthesis of the two contradictory elements—the art of love and the art of fighting.

Japan's defeat in war led him to redefine his art as one of peace and partnership rather than competition and combat. Although we kids could have been viewed as a bunch of criminals for not complying with the prohibition on martial arts mandated by the general headquarters of the occupation

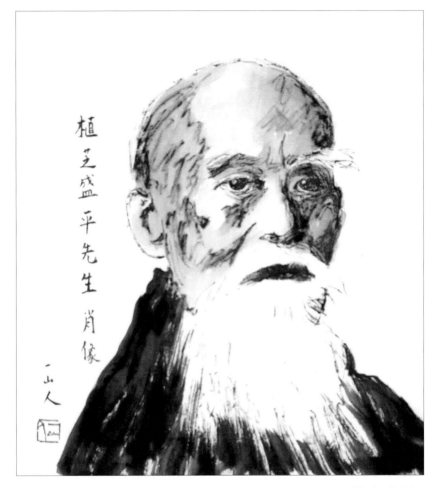

植芝盛平先生肖像

一山人

Morihei Ueshiba

forces, we were students of a master who was pioneering the martial art for peace. We were his guinea pigs.

I was perhaps his worst student. Eventually, I had to quit and leave for Tokyo to be an apprentice printer, as my family was so poor. Nevertheless, the master offered me the gift of a rank, which was equivalent to a black belt later in the aikido community, an adaptation from judo's ranking system. When he had a chance to talk to us individually, he would often say, "Please take care of aikido." I felt from him a sense of being entrusted with the teaching and still believe I am responsible for transmitting his teaching in some way.

The world must have learned from the bitter failures of severely oppressing and humiliating Germany after World War I, which caused the emergence of fascism. The occupation of Japan by the Allied Forces under the command of General Douglas MacArthur was by contrast generous and helped Japan to reshape itself as a democratic and peaceful society.

Several years after my training with the master, martial arts became legal again as Japan regained independence. My fellow students started teaching the art in schools and community centers, and eventually all over the world. The number of practitioners increased to thousands, millions. Meanwhile, I became a painter, after studying aikido with the master only briefly. I was a dropout from the warrior's path.

I moved to the United States in 1977. The scale of my brush has increased over the last thirty years. Its shaft was as thick as a finger, then a thumb, an arm, and finally a human body. The movement of the brush became ever more sparse and decisive, to the point where I would create a large painting with a single stroke. Decades after the death of Ueshiba, often without my knowledge, I was still in the process of learning from him. Through visual art, I gradually experienced what he was demonstrating in his subtle movement with free-flowing breath force—intensity, effortlessness, and a spirit that accepts all the energy coming at him and turns it in a positive direction.

In the early 1990s I was mainly using black paint on white canvas. But when asked to participate in an exhibition at the Zen Hospice, a residential program in San Francisco for those in the process of dying, I thought a black-and-white painting would not be appropriate, as it might not be uplifting or

healing for the residents. So I decided to use color. A multicolor Zen circle on a canvas scroll was the idea I settled on.

In June 1993, I stretched a canvas, about five and a half feet wide and seven feet long, over a wooden panel that was laid down on the floor of my basement studio in Berkeley, California. After priming the canvas with white gesso, I put together strips of felt with raffia straws, enough to draw a line over one foot wide, and bundled them up around a wooden shaft. I poured generous amounts of acrylic paint here and there on the canvas. Overlapping spots of paint together formed a circle, which touched the sides of the canvas. The top of the circle was red, yellow, and golden, and the bottom had darker colors.

I wet the "brush" with light parchment-colored paint, stood on the canvas, and traced over the circle with the brush almost in one breath. The paints washed together, forming a complex mixture of colors, yet retaining an uninterrupted flow of the brush movement. I thought it was a fair representation of a world with joy and hope.

While I cleaned up, went away for a cup of tea, and came back, the paint on the canvas was still moving slowly, creating marble-like patterns. The very dark blue puddle in the bottom found a path into the center of the circle and started running toward the upper right. I could have stopped the traveling of paint by vacuuming or blotting it, but I just watched it. It seemed that the circle was sending a message. After several hours, the circle stopped changing, having become a sort of Q shape. The painting was no longer pleasing or healing, but disturbing and alarming.

I thought of giving the painting a dark and ominous name. But, finally, I decided to name it *A Small Circle*, in honor of the very tiny class my master taught in the village. It also meant that I was hoping to create a larger circle.

A True Warrior

A true warrior
does not force.

A true warrior
does not flee.

A true warrior
does not fail.

A true warrior
does not fight.

Protecting Spirit

At the height of the tension between the Eastern and Western blocs, Premier Nikita Khrushchev led the Soviet delegation to the United Nations General Assembly in the fall of 1960. Both Khrushchev and Eisenhower presented their disarmament plans to the UN, but there was deep distrust between them. While strengthening alliances with other communist nations, Khrushchev fiercely criticized the United States and harangued against the UN leadership. At the General Assembly, Khrushchev lost his temper several times. Once he interrupted a Western delegate's speech by taking off his shoe and banging it on the table.

During the three weeks of their stay in Manhattan, the Soviet delegation was housed on Park Avenue. Terry Dobson, a young ex-marine, wanted to see Khrushchev from his mother's flat, a penthouse close to where the premier was staying. He saw the premier come out to the balcony of the building. At that time Terry did not have binoculars, but he did have a rifle with a scope. He looked at Khrushchev through the rifle and said to himself, "By God, I've got him." He thought he could change the course of history by loading his rifle and firing it. Then he imagined the angry face of his mother saying, "Why did you do that?" So he put down the gun.

I heard this story from Terry in 1992, a year before his death. At that time I was assisting him in his house in Hero, Vermont, to put together his life story. At one point Terry showed me a photograph of himself as a boarding-school kid with a hostile expression, surrounded by all sorts of weapons he had collected. This picture revealed the unhappiness of the child and his potential direction toward high-level violence. When I saw this weird picture, Terry's incredible rifle story became rather convincing.

In the same year that Khrushchev slammed his shoe on the UN table, Terry Dobson, at age twenty-three, left New York for Japan. But his failure to get along there with other workers on an experimental farm, and his ostracism from that community, led him to attempt suicide. Again, he changed his mind and did not pull the trigger.

In the midst of his despair and confusion, Terry went to see an aikido demonstration. Fascinated with the beauty of the dance-like interactions on the stage, he felt a strong desire to study the art. Soon he visited the main dojo of aikido in Tokyo and met Morihei Ueshiba. Seeing death in Terry's face, Morihei completely ignored him. But later, Terry's enthusiasm to learn aikido opened the way for him to study with the master's students. Eventually, he earned the trust of Grand Master and became one of the apprentice students living with the master in the main dojo in Tokyo.

I met Terry in Tokyo in 1962, when Roy Maurer and I were translating the two Japanese books on aikido written by the master's son, Kisshomaru Ueshiba. At first, Roy and I were apprehensive that the aikido establishment had sent a huge, tough-looking American to supervise our translation. But it was hard not to like this young man who had incandescent curiosity and excitement, and an openness of heart almost to the degree of naiveté. The three of us soon became friends, and the English book *Aikido*, under the direction of Morihei Ueshiba, was published in 1962.

The O'Sensei (Morihei Ueshiba) died in 1969 at the age of eighty-six. Terry decided to go back to the United States with his wife, Tomiko, and their small daughter the following year. As a holder of the fourth *dan* (grade), he was the highest-ranking non-Japanese aikido instructor at that time.

He taught aikido in New York City and in Vermont in the way he had been trained. He was also looking for a new way to apply the teaching of O'Sensei that might work in various life situations. The stories I collected from him include a number of colorful and hilarious adventures.

One time, Terry climbed up a Vermont mountain, laboring in a drenching rain on a vision quest, to pray for a personal message from God. Then God said to him, "F— you!"

He once worked as a bouncer in a bar. Then he joined a traveling troop

of carnival entertainers. He observed their raw passion and various ways of cheating, which led to his getting acquainted with a bodybuilding hit man who would kill anyone for a petty amount of cash.

Once, Terry was hired as a truck driver in Manhattan by shady individuals who were dumping industrial waste into the ocean. He had to risk his life to get out of the job.

When he was in India, he got into a combat demonstration with a police officer who attacked him with a long stick in a full swing; Terry threw down the officer without even touching him.

The English term "protecting spirit" seems to be something Terry arrived at in introducing the heart of O'Sensei's teaching to the West. He suggested in his book *Giving In to Get Your Way* that we redefine winning and losing. He said that the way truly to win is not to compete, not to push and destroy, but to embrace the other with a protecting spirit; thus both parties can win.

In the early 1980s Terry started working with the poet Robert Bly, who was developing a men's movement through a series of seminars and retreats. Terry reminded Bly of the Wild Man, the mythical forest being in Grimms' fairy tales who inspired Iron John, a boy making the long journey to full manhood. Bly invited Terry to all his seminars and encouraged him to teach.

I heard from several men who attended the seminars how inspiring Terry was to them, and how great an impact he had in their lives. Whenever I had a chance to be with him over the years, Terry was humble, funny, and honest about his past failures, but always retained a strong presence with his thoughtful eyes and half-gray beard.

One story, not as dramatic as the others, has had a continuing effect on my life. It was early morning in the 1980s on Geary Street in San Francisco. Terry saw a tall young man walking ahead of him. He looked back but didn't see Terry. Terry saw hopelessness and death on this young man's face. The young man took a revolver out of his pocket and passed it around his back from his left side and put it into his right pocket. Terry knew that this man was going to rob somebody.

The man went into a drugstore and Terry went in behind him. It was staffed by two druggists with white hair, who looked like brothers, but there were no customers. While the young man was walking around in the store,

Terry carefully shifted his position to let him know that someone was nearby, but not too close. The young man finally left without doing anything. Terry bought a few cans of soup he had not intended to buy before and said to the druggists, "You know, that young man was about to rob you. You should be careful." Instead of thanking him, they stared at him with a suspicious look. Terry walked out stricken by embarrassment. It was likely that he had saved the lives of the old men. But they only thought that he was nuts.

In 1992 I interviewed Terry at his home in North Hero, Vermont. I was going to help him publish a collection of his stories. But unfortunately he passed away in 1993.

The First Two Times They Met

A slender man in his late twenties who, by his own description, embodied the military-industrial complex, visited a Kyoto rock garden. Upon leaving, he decided to walk several miles back to the center of the city. There he went into a bar and by chance met a man about his age with a neatly trimmed beard who spoke quietly but with such power and engagement that they spent the next day together in the man's house outside the city. This meeting became one of many remarkable encounters that changed the course of the Vietnam War. I am still awed by the story.

It was 1960 when Daniel Ellsberg walked into that bar and met Gary Snyder, who had a day off from his training in a Zen monastery. Gary, the luminous Japhy Ryder in Kerouac's *The Dharma Bums*, was known as a pacifist as well as a poet in Japan. Dan had earned his PhD in economics at Harvard, with his dissertation on decision-making processes in times of uncertainty or instability. As a member of the Rand Corporation, he had been a high-level consultant to the Departments of State and Defense as well as to Kennedy's White House, drafting a number of major US policy initiatives. His trip to Kyoto had been occasioned by a Defense Department project in which he was advising the commander of US Pacific forces on problems in the command and control of nuclear weapons. His desire then as now was passionate: to prevent the use of nuclear weapons by anyone ever again.

His mission was secret, but Dan and Gary talked extensively, with no small disagreement about pacifism. Elite of the elite in the US military mainstream brain trust, Dan was nonetheless moved by his encounter with Gary. He describes his impression of Gary in an essay entitled "The First Two Times We Met," published in *Gary Snyder: Dimensions of a Life*:

His life was more together. I was as smart as he was, but he was wise. . . . I had never met anyone like him. I felt, more than envy, glad that I had a chance to discover him, to find this particular model of the way that a life could be lived.

On that trip Dan discovered that in the Eisenhower administration authority to use nuclear weapons in a crisis had been delegated to naval commanders in the case of loss of communications with Washington. Only later, as Dan revealed, did we learn how frequently such losses of communications occurred, and how much closer we were to an accidental nuclear war than we feared.

The US bombing of Vietnam started in 1964. With a civilian ranking equivalent to that of a three-star general, from 1965 to 1967 Dan was assigned to Vietnam to provide the administration with a firsthand evaluation of the war. This direct exposure slowly led him to believe that the war was wrong. On his return to Washington, he became instrumental to Secretary of Defense McNamara in creating a top-secret history and analysis of the US decision-making process in Vietnam. Through his research, Dan discovered that the government had constantly lied about its role in the war. This discovery began to cement his conviction that public knowledge of these details would more rapidly bring an end to the war. He decided to release to the public the seven-thousand-page study he helped to prepare for Secretary McNamara, at the risk of being jailed for the rest of his life.

Although Dan had not seen or heard from Gary for over ten years, his meeting with Gary had been a touchstone, providing a model of right livelihood as an alternative way of living. His wife, Patricia, and other peace workers inspired him also. These subtle but powerful influences helped Dan to find a nonviolent avenue for peace that could never have been achieved by bombing, shelling, or the spreading of chemicals.

In September 1970, Patricia and Dan drove east from San Francisco to a forest in Nevada City, California, looking for Gary. The so-called Pentagon Papers, the work with which Dan Ellsberg had been involved, were in the trunk of their rented car. They found Gary, who remembered Dan and offered them lunch. Dan conveyed to him his intent to make public his

information about the war and thanked Gary for his role in the process of his awakening.

His disclosure of top-secret defense documents in the spring of 1971 was a powerful agent for changing public opinion about the war, and its effect was profound and broad, beyond my capacity to gauge. It is interesting to note that the *New Encyclopedia Britannica* gave much more space for its entry on the Pentagon Papers than its entry on the Pentagon itself. It says, "The release of the Pentagon Papers stirred nationwide and, indeed, international controversy because it occurred after several years of growing dissent over the legal and moral justification of intensifying US actions in Vietnam."

From my rural home in Japan I followed the stories about Dan's arrest and trial. With his indictment he faced a maximum possible sentence of 115 years. When the war in Vietnam came to a close in 1973, the court dismissed the charges against Dan, citing an extensive pattern of government misconduct in his case.

After he was dismissed, Dan continued his efforts for peace, working tirelessly against nuclear weapons. He was arrested over fifty times for acts of nonviolent civil disobedience.

Meanwhile, I moved from Japan to the United States to work as a scholar-in-residence at the San Francisco Zen Center. In 1980 some members of the Zen Center and I created a nuclear study group and started participating in the growing resistance to nuclear arms and the arms race. Among the literature I reviewed on the potential for nuclear war, Daniel Ellsberg's writing seemed most articulate and informative. I read his words many times over, trying to understand global politics and Dan's strategy for reversing the arms race.

In a 1979 interview in the Marin County (California) weekly *Pacific Sun*, Dan listed the dangers of nuclear war posed during the Eisenhower, Kennedy, and Johnson administrations with their use of nuclear diplomacy. He said:

And then the biggest use came between 1969 and 1972, when Nixon constantly made nuclear threats, as Haldeman revealed in his memoirs. These threats were all kept secret from the American public

and the world. We were repeatedly on the brink of a nuclear war, initiated by us, without ever knowing it. And the only reason Nixon gives for not carrying out the threat against North Vietnam is that in 1969 the antiwar movement was too big.

He wrote about one of the dozens of actual, potential nuclear near-disasters. A nuclear weapon had been accidentally dropped from a US military aircraft in the state of North Carolina. Five of the six safety guards failed. Had the sixth failed, the weapon would have caused an explosion larger than all the wars in human history combined.

He reported that a single Poseidon submarine could target 224 cities, and yet there were only 218 targeted Russian cities. The United States had forty-one Poseidons. With thirty thousand US and twenty thousand Russian warheads, the chances of avoiding an accidental detonation decreased daily. He warned:

> I am optimistic, but we haven't much time. We have only a few years. . . . The existence of nuclear weapons manifests the dark side of our being, a human potential not to care about other humans. The challenge for us is to learn how to encourage and broaden and build upon that first potential, our capability for concern.

Thanks to myriad resisters throughout the world, we survived those fearful years. In 1990 Patricia Ellsberg and I were part of a group of people called Prophets Without Names, trying to create a vision for a fair global economy. I remember Dan's comment that this would be more difficult to achieve than what he was trying to do, and he was right; the group didn't last too long.

Nevertheless, one night in the same year I had the opportunity to meet this living legend at the home of musicians Edie and Robin Hartshorne. Being a pianist as well as an activist, Dan played Debussy beautifully. Knowing that I was an artist, he delightedly showed me his close-up photographs of flowers.

In 1991 I had an urge to see Dan again. Edie had told me that he was writing a proposal called Manhattan Project II to undo the legacy of the

Manhattan Project II

Bringing nuclear warheads to near zero
by the year 2000

proposed by Daniel Ellsberg

project that had developed the atomic bomb. I felt the historic significance of the work and wanted to offer help. Edie took me to Dan and Patricia's home in Kensington, near Berkeley. With great enthusiasm and thoughtful detail, Dan told me about his mission for bringing the world's nuclear warheads to "near zero." He used the term "near zero" to allow for a continued measure of deterrence. To call for the total abolition of all nuclear weapons at that point would, he felt, be seen as unrealistic and would fail to gain necessary political support. But he said abolition was the final goal.

His proposal to all countries with nuclear weapons included a call to end production of weapons-grade fissile material, to end nuclear testing permanently, to adopt the principles of minimum deterrence and no first use, to abolish tactical nuclear weapons, and to reduce strategic warheads to five hundred at most, and preferably to one hundred or less by the year 2000.

I could hardly believe my ears. It was like hearing a gospel of peace in the nuclear age—a set of practical and strategic steps toward global nuclear disarmament. Dan said that some people were critical of calling the proposal Manhattan Project II since it was associated with something terribly negative. He asked me what I thought about it. I said it was a stroke of genius. The "II" expressed everything—the gravity of the project, the contrast, and the hope. His paper was published in the *International Tribune* on May 14, 1992, and in the *Bulletin of the Atomic Scientists* that same month.

The next time we met, I told him about the project other artists and I had just started, and asked for his comments and advice. I believed that his plan and ours could be complementary. Manhattan Project II could be seen as a path for ending the military use of plutonium, and our project, Plutonium Free Future, focused on ending the civilian use of the deadly substance. With Dan's help we could have contact with some key scientists and policy makers. In turn, I was able to arrange publication of his proposal in Japanese and help set up his meeting with some cabinet members in Tokyo.

When Dan and Patricia moved to Washington, DC, Manhattan Project II was set up in the office of Physicians for Social Responsibility and became increasingly visible and influential. Rumor had it that Dan had advised the Russian delegation in its negotiation of the Strategic Arms Reduction Treaty II signed by Presidents Yeltsin and Bush in 1993.

Most of my time from 1992 through 1994 was spent on the work for Plutonium Free Future, which included attending conferences in Washington, DC, New York, and Boston. Although I am spending less time in actual campaigns now, I still attend some public hearings and meetings in California that address nuclear-weapons issues, and Dan is a frequent presence. The scope of his activity and influence is phenomenal.

Just as he described Gary as a particular model of the way life can be lived, Dan, with his high degree of integrity and wisdom, is also such a model. The world has not met the challenge the Manhattan Project II has posed. Perhaps now that the year 2000 has passed, we need to reevaluate the steps and tactics set up by Dan Ellsberg, and challenge the world, asking if we are serious about our call for a world free of nuclear weapons.

Daniel Ellsburg published Secrets: A Memoir of Vietnam and the Pentagon Papers *(New York: Viking, 2002).*

Encounter

for Linda

Human to human
encountering at this very moment.
 How rare, how precious!

Human to human
knowing each other at this very place.
 How rare, how precious!

Human to human
loving each other in this lifetime.
 How rare, how precious!

Human to human
forming a family in this world.
 How rare, how precious!

The Surrender Process

The Cathedral of Saint John the Divine has occupied a special place in my heart since 1982, when my family and I lived in Upper Manhattan. I remember pushing my one-year-old daughter Karuna's stroller down Amsterdam Avenue on many mornings, passing the mammoth stone structure on the way to her playgroup. When it was my turn to help take care of the five babies, we sometimes visited the cathedral's Biblical Garden and looked for the peacock and peahen behind the bushes. I sang Karuna a Japanese song about pigeons while feeding a large flock in the sunny yard. In the late morning on my way to pick her up, I would often go into the nave to be immersed in the profundity of the grand, dark space. Once, my family and I were among the crowd observing the Easter Mass; we also attended other special events that took place in the cathedral.

Our life was a happy but constricted one. As my wife, Linda, had just started her teaching career in South Asian religious studies with a one-year position at Barnard College, most of my time went to housework and taking care of our child. We lived in a small apartment in a tall building guarded by doormen—not atypical of the city.

Lacking time or space to do artwork, I developed a fantasy of having an exhibition of one-stroke brushwork in the cathedral. I had created the genre in San Francisco a few years earlier, and it may be described as emerging from East Asian calligraphy, with influences from Jackson Pollock, Franz Kline, and my own lazy nature.

I defined one-stroke painting at that point as "a painting created in one breath in a single brushstroke, straight or curved." I kept talking to friends about my dream of a one-stroke art show in the cathedral. In January 1987, a few years after we were no longer in New York City, the coordinator of

exhibits at the Cathedral of Saint John the Divine invited me to exhibit my work in November in its Chapel of Saint Boniface. Naturally, I was overjoyed.

I thought of the exhibition as a once-in-a-lifetime joke of mine, since a Gothic cathedral and one-stroke brushwork seemed to be extreme opposites of artistic creativity. While the cathedral's construction started almost a century ago and is still going on, one-stroke painting often takes minutes or even seconds. But beyond this comparison, I wanted to touch upon the deeper meaning of the cathedral so that it would help me to explore a new realm in my art. In order to do so, I needed to ponder why people take such an enormous amount of time and energy to build a structure like this.

"Surrender" was the word that arose and stayed with me. The word first struck me when I heard Mother Teresa use it in a TV documentary. Wouldn't we need to give up many of our expectations and desires to be a part of the generations-long effort of building a cathedral? In our daily life we are often forced to surrender to "stupid" things like traffic jams, unexpected bills, or illness. Wouldn't it be more worthwhile to surrender to a higher value? What might that value be? I decided that I wanted to surrender to the unknown, vast and sacred.

When Mother Teresa spoke of surrender to God, I was reminded of the Buddhist notion of selflessness. According to this teaching, we have no permanent self, no lasting possession. It is therefore important to develop a sense of freedom from attachment to possessions, including one's view of oneself. Such an understanding is central to my art: My life as an artist has been a process of giving up. I abandoned concrete forms, then colors, shades, composition, nuance, refinement, the attempt to please, as well as the use of a seal or signature. But the last fortress I was holding on to was a certain aesthetic judgment. Now I wanted to get rid of that (at least for some time). Would the work still be art? I was not sure.

Thus an idea came to me of doing the entire exhibition in one stroke—a method that would enable me to let go of values and judgments to a large extent. Then, I decided to build two giant brushes to do justice to the scale of the world's largest work of Gothic architecture. Why two brushes? Because I have two hands.

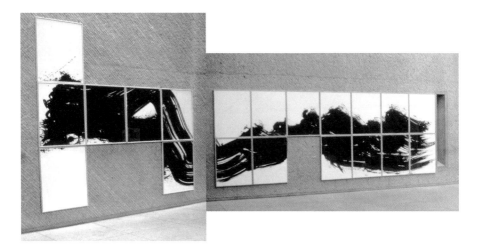

Surrender

The design process and the search for materials started in June 1987. Each brush would be seventy-five inches long, with "bristles" thirty inches long and ten inches in diameter. I found a wood turner to help build a handle and base for the brushes. He laminated poplar boards and made a bowl-like shape to contain the top base of the bristle. According to my estimate, half a million strands of shark fishing line were enough to make the bristle for one brush. After a long delay, spools of nylon thread arrived two weeks before October 9, the day I had set up to do the artwork in the presence of several friends I had invited. To my disappointment the volume of the nylon thread was too small. It turned out that *ten* million threads would be needed for the dimension I had in mind. There was no time to reorder and rewind such a large quantity of thread.

Reflecting on how brushes work, I realized that all brushes are made to create consistently even results. This was exactly what I did not want. Rather, I needed brushes that would form different landscapes here and there in the picture within a simple line. What I was looking for was a brush of odd performance. I wrapped reeds with long strips of white felt, then added a bunch of foam rubber, cotton ropes, and raffia to them.

On October 8, I was going to create four paintings with one of the brushes to test how it would perform. I poured three gallons of *sumi* (charcoal) ink into a metal basin. Of course, many bottles of liquid ink were used, as it would have taken months to grind ink sticks in a traditional way on an inkstone to get that amount of ink. When pitch-dark ink was absorbed into the "bristle," the brush was almost impossible to lift. As we usually don't think of the weight of ink, it was a rather strange realization—a certain amount of ink could strain one's back.

The living room of our house in Berkeley, California (where we had moved in 1986), was emptied out. Some plastic drop cloths and craft paper covered the floor as well as parts of the walls. Twenty white mat boards, thirty-two by forty inches, numbered on their backs, were laid out next to one another. The only requirement I had for this set of paintings was that every piece should be substantially different from every other. That meant the position and direction of the brush should be unique on each panel.

I had not prepared any sketches. But for some months before this event,

I woke every morning around three o'clock and, lying in bed, visualized creating large single strokes over and over again in bed behind my dozy eyes. This reminded me of a love poem I had written in a traditional Japanese thirty-one-syllable form, a *waka*, twenty years before:

> Again,
> again, and
> over again—
> picturing in my heart.
> Erasing and picturing.

It seemed as if this poem had been a prediction of my current nighttime routine.

Carrying one of the brushes from the basin to a position above the paper was like skating with an armful of dripping laundry. I practically threw the brush onto the paper so that splashes of ink would reach the first three sheets before the brush touched them. It felt like mud fights in my childhood, when we kids got out of control and smashed lumps of mud on each other's faces.

Friends spontaneously started chanting in deep voices, "Surrender, surrender. . . ." I laughed and dragged the wet brush while twisting it. The brush was doing a fair job of reflecting in its complex traces all the confusion in my mind. After some moments the brush movement slowed almost to a standstill while the photographer changed film. Soon I picked up the other brush and started pushing both of them together with all my might, wondering why intensity was at the same time so relaxing. It only took about four minutes to do the entire stroke, but it took three hours to suck up puddles of extra ink on the painted panels with a wet-dry vacuum cleaner.

The morning after using these brushes—probably the largest in the world—Linda handed me a note from Paul Maurer, an artist and brush maker living in Pennsylvania, whom I had met at a calligraphy conference in Portland. He wrote: "It was nice to work with you. Thank you for letting me use your large horsetail brush. I am sending you a small brush for a change." In the envelope there was a brush with an elderberry-branch handle. The bristle was about two inches long—made of six strands of cat's whiskers.

Emerging Shadows

India—with its tremendous richness of art, philosophy, and ancient sciences; its vitality in religious practices; its recent strides in modernization; its people intelligent and friendly along with those who beg, push to overcharge, or are just curious about foreign visitors; its ever-present dust, dung, and cows; its dense air and water pollution—continues to be a perplexing entity to me.

Through the burning August heat of 1988, my family and I stayed in Jaipur, a northern city with light-pink-colored brick palaces, houses, and town walls. It was originally planned and constructed by an astronomer, King Jai Singh, in the early eighteenth century. We then moved to, and settled in, another northern city, Varanasi, the most sacred city of Hinduism, which stands on the midstretch of the Ganges. Previously, in 1977 I had moved from Japan to San Francisco. It was there I met Linda Hess, a Zen student and scholar in Hindi poetry; we fell in love and got married in 1980. When we started to live in India in 1988, our daughter, Karuna, was six years old and our son, Ko, two.

On one bank of the curving Ganges River, down the steps under temple towers and faded plaster buildings, dozens of bathing terraces sit side by side. From dawn to dusk the shore is crowded with Hindus who dip themselves in the muddy holy water: sadhus wrapped in persimmon-colored cloths, holding a three-pronged stick in a cloth bag; women in saris; prosperous-looking men in white draped pants; workers in waist towels; and naked babies. A statue of a flying monkey, freshly painted with vermilion, stands in a shrine on a circular platform under a tree on the shore, attracting people who hang

garlands of marigolds around its neck. Offering incense and ghee lamps, the devotees sprinkle flowers and water on the erotic stone symbols arrayed on the platform.

What had initially brought us to India was Linda's research on Ramlila, large-scale performances of the Hindi version of the ancient epic the Ramayana. The task I had given to myself for our ten-month residence in India included studies of the Hindu concept of samsara, the continuous cycle of life, death, and rebirth, which is often explained as suffering. I had been trying to get a sense of how this common belief in reincarnation affected people's lives there. Hoping to bring forth a glimpse of "life beyond" in my artwork, I had been doing sketches of the shorelines and waves of the Ganges, which is believed to swallow the karma of millions and wash it away.

Unfortunately, in my observations I hadn't gotten any grip on samsara or life beyond or even just life. I reckoned the theme was too big. But, then again, what else had I done in my life other than being totally confused? I was rather enjoying this state of having "nowhere to go."

A few blocks away from the shore runs one of the city's longer streets, winding and bumpy, packed with peddlers behind their carts, and run-down sheds at its sides. Some people lie flat, sleeping on the pavement. Among the few new-model automobiles, swarms of scooter tricycle rickshaws roll along honking madly, and spreading toxic smoke. They dodge bikes, buffaloes, trucks, and pedestrians by a hair. Driving is certainly intuitive and unpredictable here. People fight for an inch by cutting in, making funny turns, and often driving on the wrong side of the street.

While I had been in California, the future world appeared to me as a clean and well-organized freeway where vehicles, operated by radar, would dart about at equal speeds without a chance of getting into accidents. At that moment, however, the streets in Varanasi seemed a closer image of the future, where people would inherit the outcome of the technology and consumption gaps of our generation, competing with one another in full anxiety and frustration.

As my heart went back and forth between "life beyond" and life in the world in this and the next generations, Linda and I tried to boil water to

purify it, give our children private lessons, and send the errand runner to the post office, while at the same time searching for moments to work and dream of going out by ourselves.

As I contemplated doing artwork in Varanasi, my hope was to bring forth what might only be conceived of in India, and to use Indian tools and materials. Working in this way would require me to give up much of my usual way of seeing, as well as the techniques and styles of painting that had become familiar to me while living in Japan and the United States.

So captivating was homespun raw silk, matte and slightly brown, that after seeing it for the first time there I could imagine no other material on which to paint. There were a few large bottles of India ink in town. My fantasy to use old-style paints for miniature painting fell apart when I learned that there was nothing of that sort available in Varanasi, India's capital of art. I did not have enough technical knowledge and patience, for example, to make yellow paint from the urine of a cow made sick by feeding on mango leaves, so I ended up with imported watercolors. I wish I could have said that a brush made of a bundle of peacock feathers was used on all my paintings, but in fact it was used on only one of them. I mostly depended upon European-style sable brushes purchased in Varanasi, but a white whisk, made of a wild cow's tail for religious rites, did serve me as a brush. I additionally used a toothbrush, as well as a Tibetan coin, as painting tools.

What is most striking to me in Indian perspectives, or rather states of mind, is the way Indians look at time. Whereas futurists in other countries tend to discuss matters that will happen in ten or a hundred years, people in India seem to think in terms of samsara—many lives before and after this lifetime—a sense of which I sought to explore in the process of creating my series of paintings.

Before living in India, I would usually paint by swiftly sweeping a large brush, which was dipped in pitch-black ink, just once across one or more pieces of white paper. In this way, a lot of bristle movements would appear on the picture, allowing such "accidental" effects as splashes and drips. In India, however, I felt that expression of movement might get in the way in my *Samsara* series, where I intended to capture a sense of timelessness. When we view things on the scale of hundreds or thousands of years, there must be

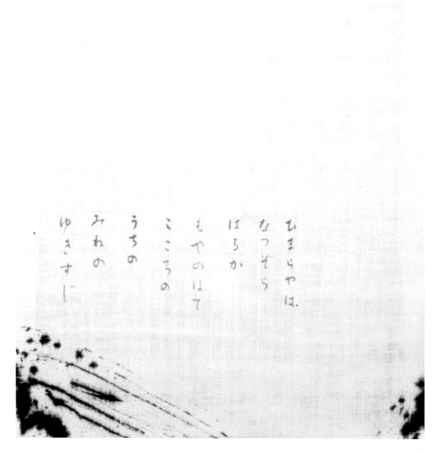

ひまらやは.
なつぞら
はろか
もやのはて
こころの
うちの
みわの
ゆきすじ

very little motion. So I decided to divide each picture into two parts—black and white—by a simple boundary line, either straight or curved.

In September and October 1988, I frequently visited the Ganges and made sketches of the water. Once at dawn, when I was sitting on the terrace of Tulsi Ghat watching people worship and bathe in the sacred river, a poem came to me. (This might give you the impression that I was always an early riser when, in fact, I went there before sunrise only that one time with one of our housemates, Manon Lafleur from Canada, who made sketches at the bathing shore almost every day at dawn.) The poem, which is in the *waka* form, may be translated from the Japanese as:

> Day just breaking
> Ganges riverbank
> floating,
> swirling
> marigolds

In October and November about thirty *waka* poems fell on me. One late afternoon I hired a small boat and took my son, Ko, who had just turned three years old, from the highly populated west bank of Varanasi across the low winter water to the other shore where not a single soul abode—just washed-away bones scattered on the water's edges.

> Surrounded by vultures
> dot by dot
> shadows emerge
> sand dunes
> on shore

The vultures in the sky encircled us, and yet were completely still. It felt as if they were waiting for the death of somebody. It could have been the death of myself or my boy. Perhaps even the human race. It was a strange sensation, giving me a glimpse into time spans stretching beyond the realm of imagination.

In December I completed studies for seventeen paintings. Each of the actual paintings was to consist of a black and a white space as well as a poem inscribed in color. At this point I had a rough idea of how the space would be

divided, with the poem placed in each of the thirty-two-by-thirty-seven-inch pictures. Making preparatory designs and studies was quite new for me, a one-stroke monochromist. I also used color for the first time in thirty years. My youthful practices of oil painting, copying ancient Chinese calligraphic masterpieces, and writing poems in Japanese all came together.

In January 1989 I started creating the final pieces. I wanted the black to be solid—a place where all things would merge and segments of time would dissolve. This would represent the darkness where no logic or dualistic thinking could reach.

While filling a large section of silk with a number of rough brushstrokes, I developed a fascination for the interaction of the black ink and the extremely sensitive Bengali textile. It then occurred to me that I should leave the brush marks as they were, instead of painting over the black portion entirely flat. Long, thin lines running in various directions would represent stars in the night sky; a number of dots stamped with small brushes would suggest millions of stupas; and overlapping spirals would be portions of continuous cycles of rebirths. Each block of darkness on the paintings came out differently, often with white openings seen through the black lines. Some blocks of darkness were almost white with slight suggestions of shadows created by a few brushstrokes.

Although I started out with studies that tried to represent ultimate darkness, during the process of creating the final pieces I found myself thrown into the realm of incomplete, contradictory, ambivalent shadows. These shadows, each having a unique texture, certainly did not represent the timelessness that I first intended to express. But this process of my working led me to suspect there are many versions of timelessness, and that we all have our own unique interpretations of nonduality: the oneness of all things.

PART TWO

Engaged in Our Time

Our Time

This is the time you and I share.
 yesterday, today, and tomorrow—
 time for reflection.

This is the time you and I share.
 a decade ago, now, a decade in the future—
 time for love.

This is the time you and I share.
 one hundred years ago, now, one hundred years in the future—
 time for action.

This is the time you and I share.
 one thousand years ago, now, one thousand years in the future—
 time for vision.

Art in a Time of Global Crisis

This short essay was written in 1987, when no one had any idea whether the Cold War would ever come to an end. We are still in a global crisis, but in another form.

Art in a period of widely perceived global crisis can never be the same as art in more stable times. Placid ripples of lake water on canvas may reflect the deadly poison of factory waste. A photograph of a family dinner may convey messages about the millions for whom half an egg is a mere fantasy. A tender voice singing a lullaby may compel us to remember the massive nuclear attack that could occur at any moment.

Artists need audiences. More fundamentally, artists need people to love and be loved by in turn. Artists need landscapes, dreams, and ideas. Just like other beings, artists need earth to stand on, water to drink, and air to breathe. Artists need the world; without the world there can be no art, no artist. Thus global survival is the primary issue for artists, just as it is for all other human beings.

We could try to ignore the terrifying situation in which we have been living since the onset of the nuclear arms race. We could try to regard art as separate from our political concerns. We could try to deny art as a tool for social change. Art could remain innocently pleasing. But we cannot, in the end, escape from reality; we need to put out messages of our utmost concern to those we care for. Many artists have started working with global awareness, and I feel encouraged by being a part of an invisible community of socially engaged artists.

A completely nonpolitical person, I moved from Japan to the United States in 1977, as I mentioned earlier, to be a scholar-in-residence at the

San Francisco Zen Center. I made English translations of writings of the thirteenth-century Japanese monk, Dogen, and texts regarding the rituals for dharma transmission. I taught courses on the history of Japanese Buddhism and Japanese literature at the Zen Center.

In that year, while I was typing a manuscript, which later became a book entitled *Moon in a Dewdrop: Writings of Zen Master Dogen*, it occured to me that this book might never have its audience. I was aware that some missiles with nuclear warheads were aimed at our city by Soviet submarines. They could attack us any day, at any hour of the day.

I said to Richard Baker Roshi, the Zen Center abbot at the time, "I think the dharma transmission we are preparing for your advanced students is important. In the event of a nuclear war, however, there might still remain dharma, but there would be no people left to transmit dharma to. Don't you think we should try to secure the lives of people on this planet?" Richard agreed and gave me permission to start a nuclear study group at the Zen Center and work with its members. The study group quickly went beyond the confines of "study" and became active—organizing film viewings, talks and discussions, letter-writing campaigns, demonstrations, and a weekly vigil in downtown San Francisco.

My first antinuclear artwork was designing a logo for the World Suicide Club, founded by David Chadwick, a wild Zen practitioner. David and his friends distributed a bumper sticker with an image of a mushroom cloud and the slogan "It's Going to Happen." The logo I created was almost an anti-logo— just a blob of black brush paint, which was meant to be neither tasteful nor appealing at all. When Ronald Reagan visited San Francisco in 1982, a bunch of people carried placards that said, "Welcome, President Reagan. World Suicide Club." It was black humor that reflected the fearful spirit of that time.

In late 1986 I conceived of a series of paintings called *Stop the arms race, or . . .* The paintings would represent images of the world's destruction in a thermonuclear war. As a brushworker, I thought of using lots of splashes and drips, as well as bursting gushes of pitch-dark ink. I wanted the exhibition of the paintings to travel, so the paintings needed to be small enough to be easily shipped by air cargo or checked in airplanes. Accordingly, I determined that the picture frames should be twenty-four by thirty inches.

Stop the arms race, or . . . 10

In March 1987, I laid out four ivory-colored illustration boards on a floor of the house my family and I lived in. With two fairly large brushes I drew two violently explosive curves across them. I was not concerned with details of the brush effect, as I did not think the end of the world should necessarily be confined to my aesthetic expectations. The next day I painted another set of four pieces again with one stroke, thus completing the series of sixteen paintings in four days with four strokes.

On one of the boards I pasted a baby's striped shirt, which suggested a child's body lying on the blasted ground. (My son was one and a half years old at that time.)

While preparing for the birth of the artwork, I thought of asking people to send me brief statements that complete the sentence: "Stop the arms race, or . . ." After asking some friends to give me names of others they knew, it occurred to me that I was excluding those friends whom I did not invite by assuming that they were not engaged in stopping the arms race. It did not feel right for me to be selective.

I wondered whether being active is something many of us do daily, whether we notice it or not. Imagine what would happen if we didn't stand in lines, stop for pedestrians, or train our children to be nonviolent. Some peace activities are prominent, but most are invisible. Just as it is said in Buddhism that everyone has buddha nature, I reflected that everyone has "peace worker nature." So I decided to ask everyone I knew to contribute their statements.

By the time the first exhibition of *Stop the arms race, or . . .* was held at the LiveArt Gallery, San Francisco, in March 1987, I had received responses from over sixty people. I printed each person's words on a sheet of paper and pasted all the messages on the walls, mingled with the paintings. Some of their statements were straightforward, some artistic, some funny. Often they came out as somber or tragic.

Stop the arms race, or the birds will have no worms; our cats will have no birds to chatter at; nothing will fly or cry.

—PAMELA B. BROOKS

Stop the arms race, or we will, collectively, become one very large, and very ethereal, homeless person.

—ROB LEE

Stop the arms race, lest the moving finger writes on without us, spells our common doom.

—SANDY DIAMOND

People also gave suggestions for alternatives:

Stop the arms race and start cooperating to feed, clothe, and house the people of the world.

—WILL WALKON

Stop the arms race; stop paying for the arms race; stop paying war taxes. Pay attention to children instead.

—ROBERT AITKEN

Stop the arms race by embracing a new image of invincibility which arises from the individual consciousness that is truly at peace with itself.

—LINDA G. SCHEIFLER

I had also asked friends to describe their life's work and what they had done or were doing. It was a moving experience for me to get in touch with the diversity of things people do: working for a free clinic, writing a documentary poem, painting a banner, civil disobedience, organizing a "cultural park" project, organizing international meetings on peace and war, helping alcoholics, hospice work for people who have AIDS, being a consultant to the United Nations, or simply trying to be human. There are many imaginative ways to work for peace.

During the first year, *Stop the arms race, or . . .* was seldom exhibited, partly because I was worried about insurance. Who would pay for it—the host, art patrons, or me? And who would look for angels? (I was ill-suited for fundraising.) Then I decided I would make new paintings to replace lost or damaged pieces in case of accidents. It seemed to be an obvious solution,

since each painting consisted of only a quarter stroke. Soon these statements and paintings were scheduled to be exhibited in a university, a public library, meditation and conference centers. People in the United States and overseas had offered to host or arrange viewing the works.

When I was participating in Zen practice at the San Francisco Zen Center, I often wondered about the significance of the part of the chant done before meals: "the third portion (of this food) is to save all sentient beings." Can we physically save all sentient beings? Or is it merely a symbolic phrase that doesn't mean anything? It seemed ironic to me that ever since we began constructing systems that could destroy the entire planet, we, too, have the power collectively to save all beings by working toward a world without such destructive devices.

One of an artist's most urgent roles is to help transform people's consciousness in the direction of a world in which we do not have to fear global suicide. We do have the power to make a difference, if we act before it's too late.

Not in Our Name

No war in our name.
No attack in our name.
No murder in our name.
No weapons export in our name.
No weapons research in our name.
No weapons production in our name.

Don't lead the world with terror.
Lead it with inspiration.

If We Go to WAR . . .

When the US government plans to attack another nation, people who oppose the military action try everything to stop it. Having gone through the first and second wars with Iraq, it seems that we are repeating the nightmare. And yet we peace workers are getting stronger and stronger. It may not be so long until a majority of citizens will awaken, speak, and act for peace so that the government will be unable to pursue its destructive policy. This short essay was written in 1991 soon after the first Persian Gulf War.

The ominous message of the billboard, displayed on a brick building on G Street, San Diego, lost its sense as soon as the Persian Gulf War broke out on January 17, 1991. An explosive black brush mark across the giant poster had suggested the massive destruction likely to occur in the approaching war. The handwritten words on the picture said, "If we go to WAR . . ." Now that the US Air Force had started pounding Baghdad, the "if" had become history.

A man in a white jumpsuit climbed up two service ladders to the billboard frame, carrying a bucketful of paint in his hand. Although he looked like a worker from an advertisement company, he was trembling in fear, as he had never climbed up so high in a narrow, open area. Having inched along on the catwalk at the bottom of the billboard to the left side of the poster, he splattered red paint over the words "If we go to." Some of the paint dripped down on the picture, splashing on his tennis shoes. Now the sign read, "WAR . . ."

The San Diego Tribune of January 19 reported:

> An anti-war billboard, visible downtown since early last month, was dramatically altered yesterday by a prominent local artist who

helped create it. However, within five hours, the "bloodied" billboard was abruptly covered over by the company that owns it.

This half-page article in the Gulf War section of the paper, revealing the actions of Mario Uribe from a group called Artists' Response Trust (ART), concluded:

In addition to the billboard, ART members designed and distributed nearly 1,200 posters using the same slogan and artwork. Uribe said he marked the posters in his building with a red handprint late Wednesday and asked others to do the same. "I had hoped I wouldn't have to do this," he said.

It was August 2, 1990, when Iraqi soldiers and tanks stormed across the border into Kuwait and seized the tiny country of tremendous wealth. Soon after that I learned that Daniel Ellsberg, an outstanding peace activist and expert in military affairs, predicted a 50 percent chance that the United States would go to war with Iraq, whose army was one of the most modernized and the fourth largest in the world.

Dan's assessment of the Middle Eastern situation forced me to make a choice: to do nothing and let the war happen or to be part of an effort to prevent the breakout of war. As a fourteen-year resident of the United States, I chose the latter. A few weeks later, in mid-September 1990, two friends and I performed a piece called *If we go to WAR . . .* in a bookstore in Oakland. While Edie Hartshorne played the flute and drum, Joshua Arone, a young actor, read the first part of my poem:

> Massive attacks. Counterattacks.
> Explosions all over—air, earth.
> Fire on sea, desert, villages, and towns.

I dragged around a human-sized brush in a dancing motion over the ten panels of illustration board spread on the floor, creating a chaotic brush line. When I stood in tableau, Joshua continued to read. I then proceeded to paint.

Billboard

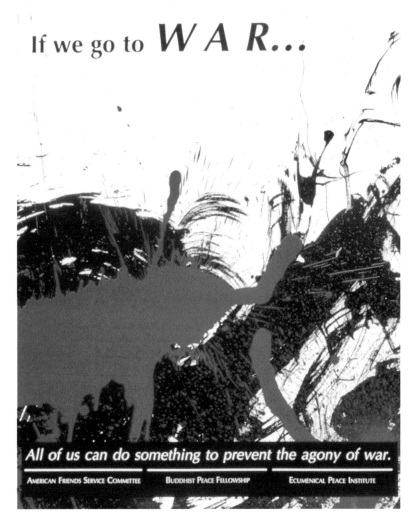

If we go to WAR . . .

Schools are crushed, houses disappearing.
Nothing is standing in the cities anymore.
Blood. Pieces of human bodies.
How many mothers are killed?
Babies stop screaming and breathing.
Hundreds of our young people get shot.
Their faint voices calling their mother.

At this point Joshua began to splatter red paint over the panels, which evoked the shocking sensation of witnessing wounded civilians and dying soldiers.

Who has created this hell?
Who is going to start this war?

I finished painting, kneeled, and leaned on the handle of the brush. Edie concluded our appeal with the weeping sound of the ceramic ocarina, a three-chambered wind instrument. Both the audience and the performers sobbed. I felt many of us were bonded with a new determination to work for averting the horror of war.

Soon after, a designer friend and I used the image on one of the panels from the painting performance and created a poster with the words "If we go to WAR . . ." This black-and-red poster was jointly issued and distributed by the American Friends Service Committee, the Buddhist Peace Fellowship, and the Ecumenical Peace Institute. I spent more and more time organizing meetings, distributing posters, and giving out postcards with messages for President Bush and members of Congress. I also joined Edie and other friends who worked with children, parents, and teachers to make buttons with peace messages using their handmade artwork.

In October the second performance was held at an art gallery in San Diego. After painting another set of illustration boards, I asked Mario, the organizer of the event, to find a way to put a brush image on a billboard with the same slogan.

Mario called up billboard companies and learned that one of them had a public-service space available. He formed a group of artists, gave it a name,

and sent the company a design for the poster. He said in the proposal, "This is not a political statement. It is simply a human response to both the concept and the reality of war and its implications for our community, our country, and the world."

The vice president of the company approved the project as a display of artwork but not as a statement. Mario projected a photo slide of the design onto butcher paper spread over a large wall. Five volunteers traced the design. When the paint was dry, he rolled up the paper and delivered it to the billboard company. It was a low-budget operation, with only the cost of the paper and paint. He sent a press release to news media and made follow-up calls. This is how the news of this anti-war billboard hit the local TV news.

To the dismay of many of those who tried desperately to stop it, however, the war started and tens of thousands of people were injured and killed. Huge environmental destruction took place. Kuwait was "liberated" by a sweeping victory of the Allied Forces in less than three months. Although Allied loss of life was much smaller than originally feared, there were military casualties, including those by "friendly fire." We should also not forget that countless Iraqi civilians were killed or suffered from injury, sickness, and starvation.

For the victors, war is over and soon forgotten. For the losers and victims, the war has no end. The degree of their despair, humiliation, and vow of revenge cannot be experienced or even imagined by the victors. Our society, our entire civilization, may continue to be threatened beyond our knowledge for years and centuries by the determined will of numerous fanatics on the losing side who have vowed to avenge their losses. War only plants the seeds for other wars. In this regard, there is no cost-effective war, nor is national or international security achieved by oppressing the other side.

One lesson we learned from the Gulf War is that the United States can send enough military forces within a matter of weeks anywhere in the world to wipe out the armed forces of almost any nation. Peace groups ought to develop the capability to mobilize massive warnings and protest as soon as the potential of a war becomes imminent. Thus, informing the public and cultivating readiness for crisis during peaceful times is crucial. Peace activists should all know how to design, print, and distribute posters, fliers, and

Can we stop violence non-violently?

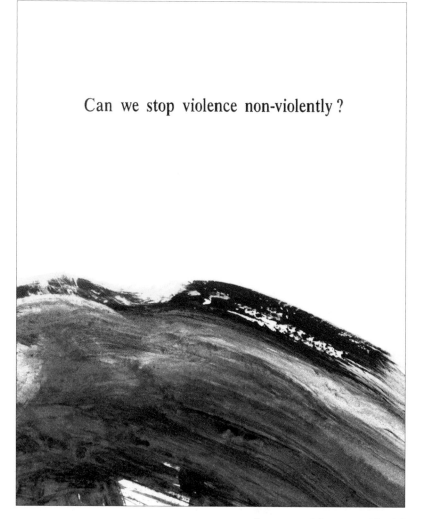

postcards within days. Establishing systems to send action alerts by phone, fax, and Internet will enhance the ability to conduct convincing campaigns.

People in all congressional districts could coordinate putting up billboards with common messages. Wouldn't it be rather difficult for the government to go to war when the posters urging them to seek peaceful solutions are flooding Washington, DC, and thousands of billboards are put up throughout the nation?

Preventing war, however, is merely the beginning of the quest to stop violence. The Gulf War was an unfortunate way to force Iraqis out of Kuwait. This leaves us a disturbing question: If we had succeeded in preventing war, how could we have put an end to the systematic atrocities inflicted by Iraqis in Kuwait? In other words, how do we stop violence nonviolently? This is one of the fundamental human dilemmas, which I call "koans for planetary survival." (Koans are questions in Zen training given to a student by a master that need to be investigated intuitively and experientially beyond intellect.)

We may find evidence in the future that the world was close enough to recovering Kuwait's sovereignty without going to war. I would like to see comprehensive studies conducted on various alternatives the world had for averting the Gulf War. Once we learn how many choices we did have, we will be able to use the knowledge for preventing future wars.

Peace in Sorrow

Peace is crushed,
Peace is in sorrow
 with every land mine we export.

Peace is crushed,
peace is in sorrow
 with every bomb we drop.

Peace is crushed,
peace is in sorrow
 with every battle we fight.

Peace is crushed,
peace is in sorrow
 with every war we win.

Let peace not be crushed.
Let peace not be in sorrow.
Let peace be the victor.

Amazing Turn

The "peaceful use" of plutonium for generating electricity was being promoted as heralding a new era of "renewable" nuclear energy among technologically advanced nations, particularly after the oil crisis of the 1970s. When plutonium is burned as fuel in a fast-breeder reactor, more plutonium than the original fuel is produced, so it was viewed as "dream energy." The idea of a "peaceful use" of this material appeared at best misguided and at worst deceptive.

Plutonium invites environmental disaster, as its lethal dosage is one millionth of an ounce; if even a small portion of the cargo were to be released into the air or sea, it could be catastrophic to the population and environment of a region. It is harder to control than uranium, and in the case of a meltdown, a large surrounding area, possibly the size of France, would be uninhabitable. Besides, plutonium is the principal component of hydrogen bombs, and it is rather easy to assemble crude nuclear bombs with it, so the spread of plutonium could cause nuclear-weapons proliferation, which the world fears. Thus, by 1980 most countries had given up plutonium-based energy projects, but Japan had not. As the nation gets most of its petroleum from abroad, the plutonium energy program was Japan's top national project for becoming energy independent.

Unable to separate massive amounts of plutonium chemically by reprocessing wastes from regular nuclear reactors, Japan had commissioned French and British plants to do the work. The official plan by the Japanese government was to transport over thirty tons of plutonium from Europe to Japan in twenty years.

Japan was also building a huge nuclear complex, including a plutonium reprocessing plant, in Rokkasho Village, at the northern tip of Honshu, the

main island. According to the announced plan, with this and other new facilities Japan would be able to produce two hundred tons of plutonium over the next thirty years—as much plutonium as was contained in the combined nuclear arsenals of the United States and the former Soviet Union.

Mayumi Oda, an artist friend who was living in Muir Beach, California, not so far from my home in Berkeley, called me up in early January 1992 and told me about her goddess's message that she should try to stop Japan's plutonium energy program. Mayumi is renowned for her paintings and silkscreen prints of goddesses. Her work is colorful, sensuous, and playful, yet deeply spiritual. It is often based on traditional Buddhist iconography, but she creates work in her own style and adds her own interpretations. I had not known that she would talk to her goddess or, rather, the goddess would talk to her, but I was not surprised. Some Japanese people have shamanistic tendencies and talk about communicating with the divine through their intuitive power. I was rather used to such talk, as my father and many of his students would often practice receiving messages from gods.

Responding to her request to help, I said I would be happy to do so and suggested that we ask members of KAI to work with us. KAI, a word that means "meeting" or "assembly" in Japanese, was a group of about thirty Japanese people living in the San Francisco Bay Area. As soon as the Persian Gulf War had broken out, some of these Japanese people had gotten together and formed study groups on the Middle East and Engaged Buddhism. I had facilitated the study of Thich Nhat Hanh's teaching, using the draft of my Japanese translation of his books *Being Peace* and *Heart of Understanding*. Mayumi had attended some of the meetings.

By the time Mayumi decided to take action, we had all been informed of the grave implications of Japan's plutonium project in its formative stage by filmmaker Kiyoshi Miyata from Japan. He had visited KAI and given us full warning.

Now it was time to see how the principles of Engaged Buddhism we had been studying might be applied in global-scale environmental action. I also wanted to see how my study of aikido decades before would help, since I had regarded aikido as an art of achieving breakthrough on personal, relational, and social levels.

In the following month, several Japanese activists and artists who lived in the Bay Area formed a group called Plutonium Free Future. At that time, it had seemed impossible for any groups or nations to change the direction of Japan's perilous plutonium energy program. The Japanese public was mostly unaware of the issue. A number of major corporations supported the program, and no political parties or allied nations opposed the policy. Japanese scientists and engineers appeared to be fully capable of pushing toward a major technological advancement in this field.

Our group decided to focus on the first shipment of plutonium heading from France to Japan in late 1992. Within one month of our first meeting, we created a booklet entitled *Japan's Plutonium: A Major Threat to the Planet*. We warned in this booklet about the danger of the plutonium enterprise, and asked organizations overseas to collaborate in stopping the plutonium shipment as a top-priority world environmental issue. We could provide reliable scientific information in this booklet, as Kiyoshi gave us all the necessary data. A nuclear chemist, Jinzaburo Takagi, a colleague of Kiyoshi's and one of the most prominent critics of the plutonium-energy venture, gave us full guidance and checked every word in my draft of the booklet. I myself, secretary of Plutonium Free Future, had known so little about this element. So I went to the library and learned that plutonium had been discovered by Glenn Seabourg in 1942 on the Berkeley campus of the University of California, during research for developing atom bombs. Coincidentally, the garage in my house in the same city had become the operations center of Plutonium Free Future.

We decided to send a representative to the Earth Summit in Rio de Janeiro, Brazil, and I was asked to be the one. In April 1992, I brought a suitcase full of our booklets to the huge gathering of nongovernmental organizations called the Global Forum and talked to their representatives about the problem, asking for collaboration. Mayumi went to Japan and formed a group of women called Niji no Hebi (Rainbow Serpent) as a sister organization to Plutonium Free Future. Individuals and groups who were against the shipment were coming together. We started to have US-born members of different ancestries, and a number of friends gave us money or sold our group's T-shirts for us. Foundations started giving us grants.

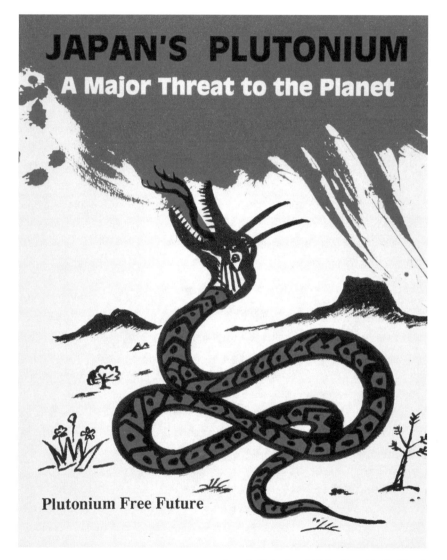

Japan's Plutonium: A Major Threat to the Planet

Meeting with lawyer Julian Gresser was perhaps the pivotal point in our campaign. He had taught Japanese environmental law at Harvard, and at Doshisha University in Kyoto (in Japanese). Once an adviser to the Japanese cabinet, he was a consultant to groups, corporations, and the European Community in negotiations with Japanese corporations and government officials. We knew that an American expert would be a great help, since none of our Japanese members had the experience of negotiating with our own government.

It turned out that Julian was a practitioner of Zen and aikido. He said that we should identify one individual who was a principal decision maker, understand his pain, and apply all our pressure on him to help relieve the pain; when the person received an overwhelming force, he would understand the potential consequences of the destructive program for which he was responsible, to the point where he would have to give in. I immediately understood that Julian was talking about an application of aikido's *yonkyo* (fourth technique), which is to take hold of the back of the opponent's wrist and give a "hand sword" push, using one's entire body as leverage. There is a small area on one's wrist that hurts tremendously when someone else applies pressure to it.

How brilliant! Compassion is not, as commonly seen, merely kind speech and a gentle way of relating to and accepting others. In Buddhism, Avalokiteshvara is regarded as the embodiment of compassion. This bodhisattva, as one who helps all to awaken, is sometimes represented with eleven faces. Most of the faces have smiles, and one has laughter. But one face has a very fierce expression. If our child underwent a life-threatening assault, wouldn't we yell out and risk our lives to protect the child? Wouldn't we have a fierce expression? What if our neighbor is in danger? Or a stranger? Wouldn't we yell out in rage? Isn't this an element of compassion?

We need to confront, criticize, accuse, and help those who are carrying out harmful actions to realize the pain that is lodged deep in their own hearts. They may not be examining critical issues; they may be ignoring responsibilities and be unaware of the destruction they cause others and themselves. That is pain. To help them realize and remove the pain can be an act of love. Was this not a new perspective on compassion? Is it not a genuine application of compassionate challenge taught by Morihei Ueshiba, the master of aikido?

Who will guard this plutonium?

Drawing	actual size
Weight	20 lbs.
Enough to build	1 nuclear warhead
Fatal dosage	1/300,000,000 of this
Half-life	24,000 years

Who will guard this plutonium?

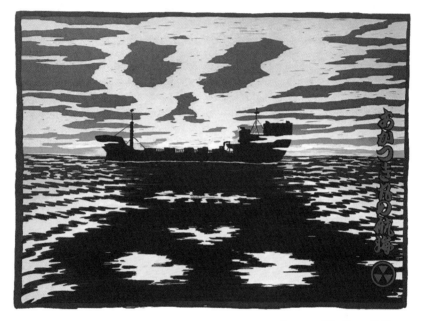

Journey of the Akatsuki Maru

We picked Mr. Kanzo Tanikawa, minister of domestic affairs, who was director of the Science and Technology Agency, as the recipient of our concerted pressure. We decided to file a petition of objection with the Japanese government against the plutonium shipment. In a letter to Mr. Tanikawa, attached to the petition, Julian raised three points:

1. How do you plan to prevent a floating Chernobyl?
2. Who will be responsible for a catastrophe?
3. What provision has been made to compensate the victims?

Then he raised his voice:

It is an affront to human decency that you stubbornly persist, ignoring all protests, when you are aware of the risks, but have resolved, for your own purposes, to conceal them; or perhaps out of laziness or indifference, you are not even aware of these risks, having never bothered to inform yourself.

Mayumi as director of Plutonium Free Future and Julian as our chief counsel signed this astonishingly harsh letter, copies of which we sent to all cabinet members as well as to the emperor and major media. In postwar Japan there is an unwritten code that we never involve the emperor in politics, based on past fatal failures. But we thought there could be an exception to this common practice for an extraordinary case with potential grave consequences, such as going to war, or when an extremely destructive policy was about to be implemented. Our judgment was that the government's plutonium program was such a case.

At the request of Plutonium Free Future and Niji no Hebi, over two thousand individuals and organizations from fifty countries quickly granted power of attorney to our eight Japanese lawyers for filing the petition of objection. This was not a lawsuit, and is usually perceived as a pre-suit action. The scale of this international legal action was unprecedented in Japan.

Fax messages surged into our garage office. The name of the designated

plutonium cargo ship was secret for a long time, but we finally learned that it was *Akatsuki Maru* (The Dawn). But its expected route was still unrevealed. Our international networking began to show results. In October we received a letter from an Argentinean organization called Foundation for the Defense of Environment:

> We have been in contact with your alerts by mail and by publications since Berlin's conference on victims of radiation. . . . Finally after a long battle, citizens and nongovernmental organizations have achieved our goal. Today the governments of Argentina and Chile decided to ban the *Akatsuki Maru*'s passage through Cape Horn.

Activists in Japan, the United States, and elsewhere made desperate attempts to stop departure of the boat from France. I focused on urging members of the European Parliament and European Commission; Japanese officials; and any others who might have influence to block the shipment for environmental-safety reasons. But the *Akatsuki Maru*, escorted by a cutter, forced its way out of the port of Cherbourg on November 7 in the midst of demonstrations at the loading dock and on sea. It was carrying 1.7 tons of plutonium, enough to make 150 nuclear warheads. A Greenpeace boat made a courageous chase over the Atlantic and around the Cape of Good Hope. But soon they lost track of the two ships.

Through wide coverage by the mass media, now the world was well informed of the danger of this plutonium shipment. The international outcry against the shipment mounted to the point that the governments of forty-three nations banned the boat from their territorial waters. The freighter was expected to arrive at the Port of Tokai, north of Tokyo, on January 5, 1993. A few days before, as spokesperson for Plutonium Free Future, I warned in a press release entitled "Nuclear Arms Race in Asia is Feared":

> The grave political implications of the arrival of massive amounts of plutonium in East Asia must not be overlooked. Although Japan has made repeated assurances that the plutonium is to be used solely for civilian purposes, the very existence of plutonium in Japan

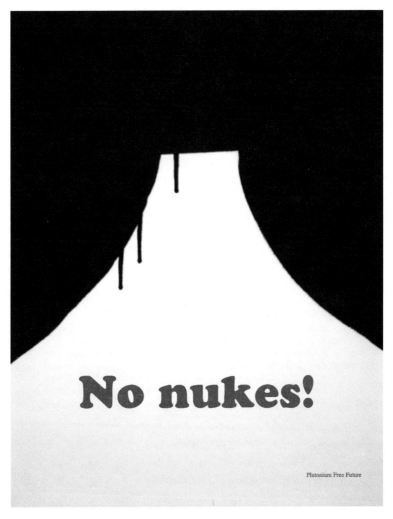

No nukes!

constitutes a threat to other Asian nations, especially those that suffered from Japanese military aggression during World War II.

The *Akatsuki Maru* did complete its controversial journey, arriving at the Port of Tokai on schedule. Soon after its arrival, newspapers reported that there was a deep split in the Japanese cabinet on the plutonium issue. Because of the strong international opposition, the government was unable to carry out any more shipments. On February 22, 1993, the *New York Times* published an article with the headline, "Japan, Bowing to Pressure, Defers Plutonium Projects":

> Japan has decided to postpone, for as long as twenty years, a series of multibillion-dollar nuclear power projects. . . . The Government's decision affects the schedule for building several breeder reactors and a second reprocessing plant. It also seems bound to cut sharply the shipments of plutonium from Europe because Japan will have far less capacity to use the plutonium fuel.

This dramatic cut in the plutonium program was subtly but officially confirmed in the revised long-term nuclear energy development plan of the Japanese government. A second shipment of plutonium from Europe still had not taken place as of 2004. The *Nihon Keizai Shimbun*, a Japanese newspaper, reported on May 11, 2004, that the Japanese Atomic Energy Commission announced a plan to give up the plutonium-based energy project and that this plan was expected to be reviewed and approved later in the year.

How was this breakthrough possible? The technological and economic problems the plutonium projects ran into certainly helped this dramatic drop. Many groups and individuals had been working on this issue years before us, and the coalition of the international groups worked beautifully. This shift in the Japanese government's national project, however, might well not have happened without the committed endeavor of our small group, strengthened by the useful advice of Julian Gresser.

Yet Japan's overseas plutonium stock is growing. It has not canceled its contracts with European industries for the reprocessing of this heavy metal,

so an announcement of a second shipment in the future may be possible. Finland and Hungary have reportedly commissioned Russian reprocessing of plutonium. A nuclear arms race due to the spread of commercial plutonium has already begun. Without a swift change in international and domestic public policy on plutonium and other nuclear power production, the threat of environmental catastrophe will remain.

Just as in any other victory, the victory of Plutonium Free Future was partial and temporary. But this experience of ours has confirmed that several committed individuals, with some understanding of political pushing and pulling, can change the direction of a huge national or multinational project. Of course we need to keep reminding ourselves that our intention has to be selfless and life-affirming in order to make the work worthwhile and effective. Don't most of us, peace and environmental workers, know this?

Up to the time when this book was being edited in 2017, Japan had not resumed plutonium shipping or large-scale plutonium production. In spite of our warning about the potential meltdown of nuclear power plants in general, in March 2011, a triple meltdown of the uranium-based Fukushima power plant took place. The effect of the disaster is widespread and profound beyond our knowledge. Germany decided to phase down its nuclear power production program. Japan made a similar plan but soon changed its mind. I believe that the twenty-first century will be an era of international competition in the technology and commerce of safe and renewable solar, wind, and tidal energy. A race for minimizing climate change needs to be intensified.

Circle of All Nations

Circles, representing complete wisdom, have been brush-drawn for centuries by Zen monks. I particularly enjoy looking at one of the circles created by Hakuin, an eighteenth-century Japanese monk. It has a thick, forceful line with a rather chaotic spread of ink, yet it retains a trace of the decisive no-going-back passage of the brush. (A number of his paintings and calligraphy are illustrated in my book *Penetrating Laughter: Hakuin's Zen and Art*.)

I sometimes grow weary, however, of the monocultural, mono-religious, and mono-gender character of traditional monochrome circles executed on a manageable scale. The *enso*, or circle symbol, appears to be monopolized by accomplished East Asian Zen masters, executed with black ink on white paper. The only layperson I know who drew an *enso* is Kitaro Nishida, an outstanding Japanese philosopher of the mid-twentieth century. I have never seen an *enso* drawn by an East Asian woman. As an artist, I have wanted to get beyond these confinements.

The idea of creating *Circle of All Nations*, a multicolored circle painted on a giant five-panel canvas to celebrate the fiftieth anniversary of the United Nations in 1995, came to me three years before the actual event. It was clear to me from the beginning that this symbol of people coming together had to be large, multicolored, and multicultural. It had to be acceptable to most people's aesthetic standards. Popularity has never been a primary concern in my art. But if the project was to involve all nations, I thought it would be a good idea to create something pleasing to the eyes of all kinds of people. This was a novel perspective for me.

If we were going to paint a giant circle, why not build the largest brush in the world? So, two architect friends helped me design a brush with an octagonal copper body and a "bristle" made of white felt. Six feet in height

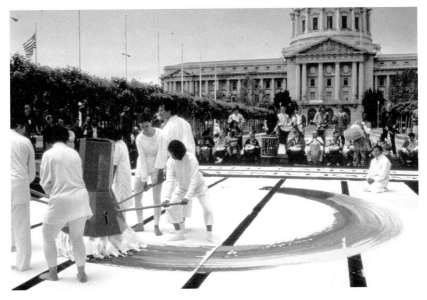

Creating the *Circle of All Nations*

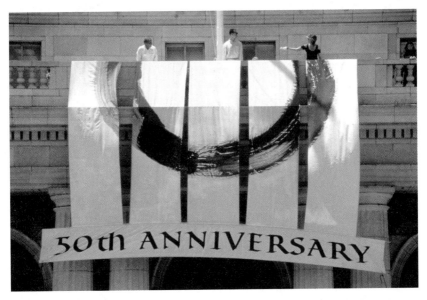

Installing the *Circle of All Nations*

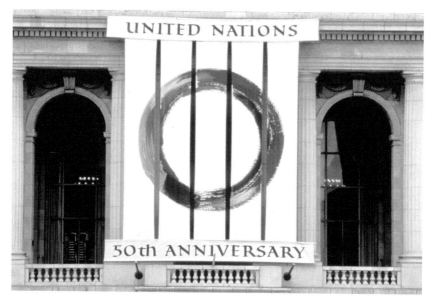

The *Circle of All Nations*, installed

and weighing 150 pounds, the brush was constructed in 1993. It had four horizontal handles to be held by four artists. During the following year, we created two large circles in public painting performances. *Circle of the World* was produced at the Parliament of the World's Religions Conference in Chicago that year; *Circulo Interno* was painted by six local artists with a slightly remodeled brush at the Tijuana Art Center, Mexico, in the same year.

My colleagues at the American School of Japanese Arts, based in Santa Rosa, California, who had produced these circles with me, were now preparing for a painting performance to be held in San Francisco, the birthplace of the United Nations. I walked around in the city with Bob Brockob, an architect, choosing potential sites for performance and installation. Bob contacted city officials and members of the San Francisco UN50 Committee. Thus the *Circle of All Nations* performance became one of the official UN celebration events. Liz Uribe, founder of the school, took on the administrative aspect of the project.

Mario Uribe, a multimedia artist, brought to the project his computer simulation and organizational skills. He and I set about creating and revising detailed procedures for the execution of the brushwork. I was used to creating spontaneous one-stroke brush paintings, so conducting rigorous color studies with Mario was a new experience. With his background in Western painting, it was natural to pour as much thinking and planning as possible into the work. Georgianna Greenwood, a master calligrapher, formed a team of five Western-style calligraphers and created two horizontal banners with the words "UNITED NATIONS" and "50th ANNIVERSARY" to be attached to the top and bottom of the painting.

"Circling the Globe in the City" was the *San Francisco Examiner* headline that reported the painting performance at San Francisco Civic Center Plaza on June 3, 1995. The event began with about two dozen international drummers led by S. Kwaku Daddy from Ghana, and with circular body movements by Haruyoshi F. Ito and members doing Shintaido, a noncompetitive martial art originated in Japan. Five children, along with Mario, poured acrylic paint—yellow, orange, red, green, blue, and purple—on designated parts of the five panels of canvas spread on the ground. The total canvas area was twenty-three by twenty-eight feet.

Surrounded by two hundred people holding the flags of many nations in their hands, four women and three men from different parts of the world brought the giant brush onto the canvas. Following directions by Mario, who was moving around outside the twenty-foot-diameter pencil-marked circle, the seven artists slowly carried the brush clockwise. My job was to hold the handle at left front and guide the edge of the bristle along the pencil line. It took about ten minutes to complete the one-stroke work.

The board of trustees of the War Memorial Building on Van Ness Street, where the UN charter was signed fifty years before, then unanimously approved a proposal that the circle be hung on the front of the building.

June 13 was the day of installation. I said to my thirteen-year-old daughter, Karuna, on our way to pick up helpers, "This is going to be the biggest hanging in my life."

She said, "It sounds so sick!"

Only with the help of Nick Weiss, a muralist and sailor, who flew from San Diego to volunteer, and ten other people who lent a hand, could we hang this monster set of canvas pieces assembled with numerous iron bars, clamps, and cables.

Sherry Chayat, a Zen teacher and art critic who had just arrived from Syracuse, New York, took me out for lunch in a café near the building the following day and scribbled these lines for me:

> Suspended majestically across the front of the San Francisco War Memorial and Performing Arts Center, *Circle of All Nations* is both playful and profound, joyous and solemn. Like a spinning wheel weaving together the colorful threads of all the different nations' flags, each clearly recognizable yet flowing into a harmonious whole, the image is the quintessential symbol of unity in diversity. In its path across the white field, the single multihued brushstroke has a lightness, an openness, that belies the physical weight of the six-foot-tall brush. Breezes ripple across the five panels of the circle, further enlivening its dynamic spontaneity, its gestural force. Marveling at its creation, one is reminded of the marvelous ideals upon which the United Nations was founded.

The painting stayed up until June 29, throughout the main events of the UN celebration. At one point, however, a three-inch-square rip was found on the corner of the bottom banner, caused by wind and rain. I asked a sewing instructor at San Francisco Zen Center to recommend a tall, strong Zen student who could reach the rip and repair it. I thought someone who had experience in sewing a *rakusu*, the simplified Buddhist robe worn over the chest, could do the work with mindfulness. Often Zen students do this as a part of their practice before receiving a lay or priest ordination.

Paul Medlyn immediately responded to my call, and the next day we went up to the second-story veranda of the building.

Soon I noticed him smiling as he stretched his body to push the needle through canvas. I said, "Is this an oversized *rakusu* for you?"

"Yeah," he called back. "It helps to chant *Namu kie butsu* [I take refuge in Buddha] each time I take a stitch."

Circle of Peace

A circle of peace.
> From its brilliant green
> I receive a hope for the future.

A circle of peace.
> In its ocean blue
> I deepen my commitment to community.

A circle of peace.
> In its sunlight orange
> I collect energy for healing.

A circle of peace.
> With its crimson red
> I carry passion to engage.

A circle of peace.
> In its full rainbow
> we find wholeness in our work.

Liberating Justice

The World Court Project is an inspiring example of what citizens can do to change the course of history. The idea of bringing nuclear arms issues to the World Court, the principal judicial organ of the United Nations, was developed by a few people sitting in a kitchen in New Zealand in 1986. They formed a group called the International Association of Lawyers against Nuclear Arms and gained increasing support from individuals, organizations, and governments over a period of seven years. In 1993 their lobbying resulted in a request by the World Health Organization that the court issue an advisory opinion on the legality of the use of nuclear weapons. The court declined this request.

When these issues were brought to the United Nations General Assembly, the United States, along with other nations possessing nuclear weapons, conducted an all-out campaign to keep the General Assembly out of the picture. But in December 1994 the United Nations General Assembly voted in favor of requesting a World Court ruling on the issue.

When the court was discussing the case, a great number of people around the globe wrote to the judges. I sent a letter individually to all fourteen judges of the court. It was based on my trust that they would declare the illegality of nuclear weapons. My letter was also meant to address all who are concerned about world peace. Here is part of what I wrote:

> Can we humans liberate justice from the confines of regional, national, class, commercial, or ideological polarization? Can we world citizens be free from the dark assumptions as old as human history that "might is right" and "victors own justice"?

The World Health Organization and the United Nations General Assembly have requested that you issue an advisory opinion on the legality of nuclear weapons. Thus you are determining whether any state or set of individuals has the right to risk the lives of millions and billions of innocent people under any circumstances. By declaring that the use or threat of nuclear weapons is inhumane, immoral, and illegal, you would begin to withdraw from a handful of nations the self-claimed right to annihilate vast portions of the earth. This would confirm that the further development, testing, production, and deployment of nuclear weapons are unjustifiable under international law. By advising the United Nations and the governments of all nations to initiate and conclude negotiations on a comprehensive nuclear disarmament treaty for a permanent abolition of nuclear weapons, you would alert all nations to the fact that they hold the fate of humanity in their hands.

If the international community were fully democratic, nuclear weapons would never be accepted. Unfortunately democracy does not prevail in the United Nations, as it has been structured around dominance of the victors of World War II. The Security Council is controlled by its permanent members. The interests of these major nuclear-weapon-bearing states, as well as of corporations that influence their policies, overwhelm reason and the interests of the majority of the world's people.

The victims of this unbalanced international system, however, are in all countries, including those that hold the power of the veto. The public knows it cannot control the use of ultra-destructive weapons. Realizing the irony of gambling human survival for their own national security, members of all generations in these states are profoundly harmed. The poverty of many US citizens could be alleviated if funds for the arms race were redirected toward public welfare and education. The continuous increase of drug abuse and crime is another symptom of this illness. The declining economies of states burdened by the astronomical cost of nuclear weapons programs are dramatically represented by the collapse of the Soviet Union.

One important step toward fully democratizing the international community is elimination of veto power from the UN Security Council. Realizing that the veto system is harming the world collectively and the nation-states individually, citizens of permanent member states should urge their governments to give up such privilege. Only when the United Nations becomes truly democratic can it be fully responsible for maintaining international peace. This will enable the international community to take measures to reduce production and trade of weapons. We need to prohibit weapons that are likely to harm citizens indiscriminately. Land mines and napalm, as well as nuclear, chemical, and biological weapons, may fall into this category.

Abolition of nuclear weapons is only one step toward actualizing a sustainable human society. But it is the most essential step. Bearing billions of people of the world in mind, I wish you the best in your historic decision-making process.

On July 8, 1996, Judge Mohammed Bedjaoui of Algeria, president of the International Court of Justice (another name for the World Court) in The Hague, announced to a packed courtroom the court's landmark ruling on the illegality of nuclear weapons. The court declared that "the threat or use of nuclear weapons would generally be contrary to the rules of international law applicable in armed conflict."

The court stressed that "there exists an obligation to pursue in good faith and bring to a conclusion negotiations leading to nuclear disarmament in all its aspects under strict and effective international control." The court, however, remained undecided "whether the threat or use of nuclear weapons would be lawful or unlawful in an extreme circumstance of self-defense, in which the very survival of a state would be at stake."

The court's advisory opinion, which was described as consultative and not binding, was largely ignored by the mass media in the United States. But I believe that the implications of this decision by the highest legal authority on questions of international law are huge. The threat of, and readiness for, nuclear attack have been the most powerful forces shaping the foreign and

defense policies of the states possessing nuclear weapons. But now, in light of the court's ruling, anything in line with Kennedy's threat of nuclear attack to the Soviet Union during the Cuban crisis of 1962 would be regarded as a criminal act.

Although there is a slim gray area regarding the use of nuclear weapons for self-defense, current stockpiles are inherently offensive. The United States would not need as many as one hundred weapons to defend itself in the most unlikely event of desperate self-defense. Therefore the use of at least 99 percent of US nuclear weapons could be defined as illegal. Although nuclear-armed states have not paid attention to this decision, at least for some time, it is clear that the court's ruling has invalidated any justification for further development as well as deployment of nuclear bombs, which Judge Bedjaoui referred to as "the ultimate evil."

Because of the nine-hour difference between Europe and California, about ten activists could demonstrate in front of the War Memorial Building in San Francisco on the same morning. I brought a large horizontal banner made by my fourteen-year-old daughter, Karuna, which said "VICTORY," followed by a drawing of mushroom clouds, and the words "ILLEGAL NOW." In front of the building we put up another sign which said, "World Court declared today that nuclear weapons are illegal." About five of us sat on the sidewalk for two hours ecstatically drumming and yelling out, "Celebration! Celebration!" Some passersby responded in excitement and joy. Cars and buses honked in agreement, while the majority of traffic did not notice this small group of demonstrators.

Tears That Soak Our Soul

The railroad track approaches its end in the middle of an enormous compound. Two pebble-covered roads run parallel to the track with ditches in between. Rows of watchtowers surround two areas of countless barracks and remaining brick chimneys inside the tall barbed-wire fences, on this gray November morning at Auschwitz II, in Poland. It had stopped raining the night before.

I stood on the ground in front of a small wooden building across the tracks. It was here that SS (elite Nazi) officers determined the fate of the Jews, Gypsies, homosexuals, and political prisoners just disembarked from the boxcars. Auschwitz I, one of the Nazis' nine hundred and eighty concentration camps, had become too small to carry out their plan to wipe out six million Jews and five million others. For this reason, they started building the second compound, twenty times as large as Auschwitz I, in its nearby village of Birkenau in 1941. It was to become the most efficient human slaughterhouse of all time.

The German officers would select people who looked suitable for forced labor and send them to the men's and women's areas. A small percentage of children, especially twins, were sent to one of the barracks in the women's area for pseudo-medical experiments. The remaining majority, including babies and mothers, had but minutes to live. They were led along the railroad track, straight to the three undressing rooms hidden underground and then to the adjacent gas chambers, each of which would terminate two thousand people within half an hour.

It is far beyond anyone's capacity to grasp the enormity of this atrocity. I myself can never know the horror, agony, and distress of even one of the thousands of people who were brought here.

For some months after I decided to come, I had been grieving with the horrible images of my own family being brought here. My wife and daughter might be pushed to one of the women's barracks, had they been lucky. My son might not be tall enough to hit the height selection rope, and I myself at age sixty-four might be judged as too old to do the labor of burning hundreds of corpses a day. So, both my son and myself might be sent walking on this road to the death factory. I could hear Karuna, my sixteen-year-old daughter, say with her sweetest voice as she always does when she parts from me, "I love you, Dad."

In my mind I could picture the faces of at least four people with the same family name from Amsterdam, one of the cities I was familiar with, that drew Nazi victims: Abraham Peereboom, prisoner number 36425 of 1942, died at age fifty in the same year; Naomi Peereboom, prisoner number 19396 of 1942, died at age fifty on August 11 of the same year, the day after her birthday (probably Abraham's wife); Pierre Peereboom (possibly their son), prisoner number 31242 of 1942, died a month after Naomi at age twenty-four; Elias Peereboom, prisoner number 7686 of 1943, brought later than the other three, died in 1943 at age twenty. Their names were among the one hundred thousand listed in the three-volume Death Books from the Gestapo lists of laborers at Auschwitz/Birkenau who died at the camps. It is estimated that more than one million people whose names were never listed were sent directly to their death upon entering the camps.

I could see the faces of some people whose names were given to me by my friends in California. Of course, the images I conjure could vary greatly from the way they had actually looked. Yet visualizing the victims gave me a tangible way to remember and honor them as individuals who had beautiful faces. The mountain of toothbrushes and combs displayed at the Auschwitz Museum is more than daunting. I could only gaze at one or two objects and think of the intricate web of memories, love, and hope that together created each person's life.

In spite of my empathic visions, I had no way to imagine what had happened to the relatives of Rudy, my wife Linda's father, who had immigrated to the United States before Hitler took power. He had never told his children

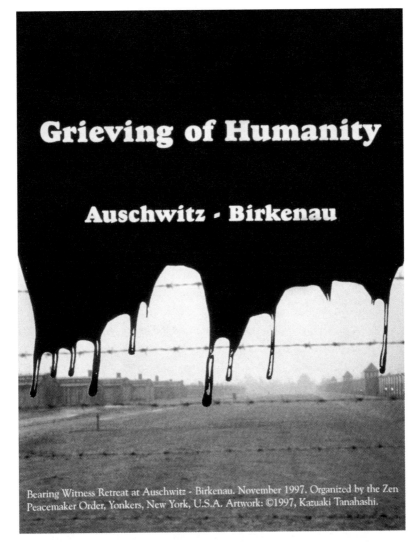

Grieving of Humanity

Auschwitz - Birkenau

Bearing Witness Retreat at Auschwitz - Birkenau. November 1997. Organized by the Zen Peacemaker Order, Yonkers, New York, U.S.A. Artwork: ©1997, Kazuaki Tanahashi.

Grieving of Humanity

about the fate of his people in Vienna, except about his own sister who stayed in the city and survived miraculously, despite being a Jewish woman. Nor did we know about the family members of Linda's mother who had come from Russia.

A participant in the Bearing Witness Retreat at Auschwitz-Birkenau, I was one of one hundred and thirty people from Europe, North and South America, and Japan. We sat forming a long rectangle at the "selection site." While most of us meditated, four people who sat in the middle sections of the four sides each read about two hundred names of people from the Death Books. Other participants who took their turns did the same. In the center of the gathering sat a small mound of rocks, on top of which was a dark-red wooden box that contained the sheets of names invoked. Flowers, ribbons, and sentimental objects were offered around the altar. It rained hard on the second day, soaking through many of our jackets. On the third day, because of the bad weather, we sat the three scheduled periods of meditation inside one of the coarsely built wooden barracks. Finally, on the last day of the retreat, we were once again able to sit all three periods outside. At one point we moved from chanting names of people separately to chanting altogether, "Name unknown, name unknown, name unknown. . . ."

The Auschwitz retreat was conceived and led by Bernie Glassman, a Zen teacher and social activist based in Yonkers, New York. Organized by his Zen Peacemaker Order, the first retreat took place in 1996. I participated in the second one, in 1997. I had known Glassman Roshi since 1982 when he ran Graystone Zendo, situated in a gorgeous estate in the Bronx on the Hudson River. He then built a bakery in the poor neighborhood of Yonkers and started service work for homeless people and those with AIDS.

His "street retreats" in Manhattan, with participants carrying just enough money to bring them home by subway while spending several days sitting on busy streets like beggars, seem to be one of the most direct expressions of oneness with others experienced in the world of Zen training. Bernie's students have been conducting street retreats in many parts of the world. He has developed an amazing way to go beyond the boundary of the haves and the have-nots. The Auschwitz retreat can be seen as an extension of the street retreats. It encourages participants to go beyond the boundary of

race and identity of descendants of victims and perpetrators, and to become open to their own potential for violence. This realization of the oneness of people leads them to compassion, openheartedness, and healing.

The most visible leader of the retreat, however, was Rabbi Don Singer from Los Angeles, one of Bernie's Zen students. On the first morning at the execution courtyard in Auschwitz I, he conducted the Kaddish, a Jewish prayer for the dead, which was offered by ten people each in a different language. Don led prayers and singing at each meditation, making our dinners reflective with his interactive singing and dancing.

During the retreat we had services from many different traditions, including Native American, Coptic Christian, Sufi, and Buddhist.

At sharing time in the evenings, some participants talked to the entire group about their suffering and that of their families. We also shared our thoughts and feelings in small groups of about ten people every morning. Hearing other people's stories reminded me of the depth of suffering that is still immanent, as well as the diversity and complexity of it. The stories revealed many different types of suffering: a young Jewish man whose parents' families had all been killed; the son of a Jewish woman and a German man who had fled to South America; an American woman who had been living in Poland as a hidden Jew; a woman who refused to speak German during the retreat, wishing she had not been a German; a young German man who felt he should be ashamed of himself but couldn't; a Polish woman who had suffered from her father's greed for power as a result of his having been deprived of safety in his childhood because of the war; a Polish woman who had grown up hearing her father's awful survival stories like fairy tales, describing her people as closed, silent, and dysfunctional survivors.

The Nazis' systematic genocide was conducted with satanic hatred, deception, and brutality, causing immeasurable suffering not only in Europe, but throughout the world. Their crime involved the entire German society that at one point seemed to support Hitler with fanatic enthusiasm. The Germans alive during wartime must have had at least some knowledge of what was happening to the Jews. Even those who were born after the liberation of the death camps inherited a heavy sense of guilt from the atrocities those in the previous generation had inflicted.

Standing at the selection site of Auschwitz II, I wept for the families torn apart. I wept for the children and their mothers. I wept for the lives of happiness and beauty those individuals could have carried into the future. I wept for the terror and agony they had to bear. I wept for their unanswered prayers. I wept for those who had believed in the deadly-wrong concepts of "racial purity," "master race," and "glory of the Reich." I wept for the darkness in the hearts of those who had taken active roles in atrocities. I wept for different forms of Auschwitz happening in other parts of the world right then and now. I wept for the shame of humanity. I wept for the wounds of the younger generation. I wept for the curse that the older generation, including myself, had to carry.

In my grief I took the brush, kneeled down, and dropped my body.

My "art supplies" were quite limited, and so were my ideas. The spirit of bearing witness in the retreat was not to bring preconceived plans, but rather the heart of not knowing. I had brought a large amount of ribbon strips of flowery colors that were used by participants as expressions of remembrance and love at various sites. I had also brought a plain black horizontal banner with sticks, from demonstrations at US nuclear-weapons sites, which had been dipped in a pond of ashes near one of the crematoria and strung on a barbed wire fence during the last meditation period.

On one of the banners was written in white letters on black, "Why do we keep testing when we know that they work well? Nevada Test Site." But in speaking with the Polish hosts of the retreat, I had realized that putting up a political message like this in Auschwitz, a cemetery and spiritual site for many, would not be appropriate, so I gave up the idea of displaying it. Instead, I shredded the black cloth into strips and made a foot-and-a-half-long brush bristle. One of the sticks was used as the handle of the brush. I had brought two bottles of ink.

As I didn't have time to look for paper for art in the nearby town, I decided to use the back of one of the monochrome posters, available at the Birkenau Museum bookstore. It had overlapping images of the light from a candle and a heap of dead bodies in a ditch. I also used a poster and a garbage bag as a pail for the ink. Rebecca Mayeno, a ceramic artist from Berkeley, California, helped me to set up and produced photo documentation. Dipping

the brush in the ink, I drew a simple thick black line, which filled over half of the paper. Some people preparing for the first meditation of the last day passed by. The Polish crew that had been filming the retreat found us and got some footage.

Rebecca helped me pull up one side of the paper. The ink created lines of shedding tears.

My participation in the Auschwitz retreat inspired me to apply this experience in East Asia. Nanjing, where an unprecedented massacre and mass rape took place soon after the Japanese invasion of China in 1937, seemed to be a counterpart to Auschwitz. I started visiting China in 2000, met experts on the Nanjing massacre, and helped establish the Nanjing Friendship Fund.

Inheriting Accountability

In the first phase of war with China, Japan took Shanghai in August 1937. Then its troops pushed westward along the Yangtze River, struggling against the fierce resistance of the Nationalist Chinese army, and approached Nanjing (Nanking), the then capital. Nanjing fell in December of that year after four days of battle.

My father, Shigeo, was commander of the first company that engaged in forced landing near Shanghai. He got injured on the way to Nanjing and was sent back to Japan.

Iris Chang's *The Rape of Nanking: The Forgotten Holocaust of World War II*, an international bestseller published in 1997, describes the battles and atrocities—massive slaughter and rape of civilians and killing of prisoners of war—by the Japanese troops. As a Chinese American, she presents a Chinese perspective on this tragic incident and the denial of responsibility by the people and government of Japan.

The Japanese version of *The Rape of Nanking* has never been published. Instead, the Japanese book *"Za Repu Ovu Nankin" no Kenkyu* (A Study of "The Rape of Nanking"), by Nobukatsu Fujioka and Shudo Higashinakano, was published in 1999. The authors are professors at Tokyo University and Tokyo's Asia University, respectively. Their study examines *The Rape of Nanking* in detail, denying the authenticity of all ten photos in the book depicting atrocities and challenging the five basic points of Chang's book.

Although the premise of Chang's book is severely challenged by these authors, I believe *The Rape of Nanking* should be read and widely welcomed in Japan, as it represents some, if not the majority, of Chinese people's views and feelings about the incident. If the Japanese don't have a good

understanding of Chinese perspectives, how can dialogue between the two peoples be possible?

Higashinakano and his colleagues founded Nihon Nankin Gakkai (Japanese Society for the Study of the Nanjing Incident) in 2002. It seems that the core members of this society are committed to meticulously reexamining historical materials in order to reduce the reported scale of wrongdoings and justify actions of the Imperial Army.

Masaaki Noda, professor of psychiatry at Kyoto Women's University, published *Senso to Zaiseki* (War and Guilt) in 1998. He selected nine ordinary Japanese men who lost their individual sense of conscience and became as brutal as demons under the circumstances of Japan's colonialism in and war on China, and later confessed their crimes. Noda's careful tracing of the personal background and feeling of each person, based on his interviews with them, presents rare materials on the guilt of Japanese participants in war.

In 2000 I traveled to Nanjing with a dear American friend—Joan Halifax, anthropologist and Zen *roshi*. We visited the Memorial Museum for the Chinese Victims of the Nanjing Massacre by the Japanese Agressors. The displays of the museum include many photographs and documents of violence, torture tools, personal possessions of victims, as well as a half-excavated site of the killing field. Some copies of the Japanese newspapers during that time demonstrate that the public was well aware of the killings of prisoners of war and the massacre in the city.

Who, among the Japanese, would not be stricken by shame, sorrow, guilt, and identification with the victims? I imagined myself holding a machine gun and slaughtering hundreds of innocent people. If I had been fifteen years older, I might have been ordered to do so. In fact, most of my father's comrades in arms participated in the battle of Nanjing.

Iris Chang introduced me to Yang Xiaming, professor of English literature at Jangsu Young Management Personnel College, who had helped in her research. I asked him to arrange a meeting with the leading local scholars of the Nanjing massacre. At the first meeting, four members of the Research Center of the Nanjing Massacre by the Japanese Aggressors, Joan, and I jointly established a "Nanjing Friendship Fund" to help conduct service work for the victims and their families.

Not a historian in this field, I am in no position to comprehensively examine historical data. But there are some points on which most people—Chinese or Japanese, left or right—can agree in regard to Japan's imperial expansion and the Nanjing incident: Japan colonized Korea, Taiwan, and the northeastern region of China—Manchuria. Japan sent combat forces to China, attacked it, and occupied a number of cities and villages, including major ones. Not vice versa. The Nanjing incident is certainly the most well known of the Japanese military actions in Asia and Pacific, for the scale of atrocity that happened in the then capital city of China. It is, however, a relatively small part of the entire chain of events that took place during the time of Japan's imperial expansion.

Through the seven years of war between China and Japan there were high military casualties on both sides, as well as huge Chinese civilian casualties and enormous losses of property. Japanese troops waged chemical warfare and conducted human experiments on the Chinese. Torture, rape, murder of prisoners of war, forced labor, systematically forced prostitution, and confiscation of property by the Japanese were not uncommon. A number of Chinese suffered from inflicted poverty and starvation. And, as is common in many parts of the world, countless indiscriminate killings in battles against guerillas occurred.

The Japanese government has refused to use the terms "invasion" and "Nanjing massacre" and has censored school textbooks accordingly. It has refused to pay compensation to the victims. The majority of the Japanese public is not actively engaged in dealing with the past actions of the Japanese troops. More than half of the Japanese population was born after the end of World War II. Talk of Japan's responsibility in the war, especially that of the emperor, has caused violence, including fatal attacks, by extremists; there is fear within the Japanese public about speaking out or taking action with regard to Japan's responsibility because of potential violence. Many Chinese still feel enormous resentment and hatred against the Japanese for their past aggression.

Now, here is my understanding of the situation: Japan's colonial expansion to and invasion of Asian and Pacific regions, including China, are historic facts that no one can deny. Members of the Japanese military forces inflicted

Nanjing Lamentation

Rapes and Devastations

atrocities upon the citizens of these regions. In many cases military personnel, commanders in particular, were accountable. The government that sent the troops held the most responsibility. The Japanese public that, willingly or unwillingly, supported war was certainly responsible. They should have known that if they sent hundreds of thousands of soldiers to a land of millions and millions of people, indiscriminate killing and mismanagement of prisoners of war would be almost inevitable.

Is the Japanese postwar generation, then, including myself, free of responsibility? At this point I would like to propose two basic principles regarding this question, which can be applied to similar cases of the wrongdoing of earlier generations worldwide.

One: As in the common legal standard, no one should be punished for his or her parents' or ancestors' crime.

Two: Just as everyone inherits privileges (such as the right to a decent living standard and education), so should everyone inherit accountability for the actions of previous generations.

If we say, "I did not do it," "I was not there," "I was not even born at that time," or "I know nothing about it," how would we resolve the actions of society in the past? If everyone in Japan ignores the past perpetuation of atrocities in China and elsewhere and avoids responsibility, there will be everlasting polarity between the two sides and hatred of many individuals toward the Japanese. (Those who participate in this polarity may be represented by branding terms like "propagandists," "revisionists," or "holocaust deniers.")

What needs to happen to reduce the polarity and hatred? I suggest the following as basic actions for reconciliation: Openly study, examine, and discuss past incidents free of nationalistic or racial bias and with respect for others. Help establish Japanese government policies for admitting past wrongdoings and compensation to victims; urge Japanese lawmakers to establish measures to enforce maximum punishments for violence that threatens freedom of speech; create occasions as much as possible for Japanese individuals to listen to the voices of suffering and the emotional realities of the victims and their descendants; and find ways for victimized citizens and the Japanese to work together in service of healing psychological wounds, including avoidance and denial.

Scholarly studies need not be limited to examining what happened. It is essential for us to know why and how the war and violence happened, and how we can avoid repeating similar mistakes. And, most important, we need to know what has been and needs to be done to reduce the suffering of the victims and their families as well as descendants, and establish everlasting trust and friendship on individual as well as national levels.

Exploring the emotions of individuals in depth is crucial. Even a limited number of people working together can help many others to open up their feelings, and this can be an essential part of the healing process.

In 1996, the Asian World Work, a workshop led by psychologists Arnold and Amy Mindell, was organized at a hotel in San Francisco by the East Asian Awareness project of Inochi. Inochi is a nonprofit organization, evolved from Plutonium Free Future, that the painter Mayumi Oda and others, including myself, had founded four years before. Arnold Mindell, author of *Sitting in the Fire: Large Group Transformation Using Conflict and Diversity*, had lectured and conducted workshops about dynamic-process work and conflict resolution in many parts of the world.

About seventy people participated in the workshop. One-third of them were from East Asia or were US citizens of East Asian ancestry. There were about thirty Japanese, some of whom had come from Japan to attend the workshop. The rest were non-Asian Americans.

Despite the rather chaotic and unstructured setting of the workshop, individual stories told by Asian Americans about their parents were daunting: they told of the suffering caused by forced labor, racial hatred, loss of family, and so on. Encouraged to speak from the bottom of their hearts, they expressed anger, and hatred, toward the earlier generation.

The participants, through role-playing games, spontaneously created scenes of violence (almost to the point of actual violence). They then changed roles—oppressors became victims. These role-plays led us to identify ourselves with the suffering and brutality we all experience as human beings. I was amazed that even in such a short time so many important social issues were quickly and unintentionally brought to light.

Right before closing the workshop, Haru Murakawa, the main organizer, suggested that the Japanese participants apologize for Japan's past actions.

Atonement: One Hundred Million Japanese

All of us sat on folded legs and bowed our foreheads to the floor. The bowing felt very, very long to me. I was filled with humility, sorrow, and pain. Mayumi repeatedly cried, *"Gomennasai"* (forgive me), and took the hands of everyone from China, Korea, and the Pacific each time she bowed to the floor. I heard sobbing from different parts of the conference room. Haru's suggestion was a surprise to me, but once we did it I realized how appropriate it was.

This Asian World Work in San Francisco infused me with the hope that people from both oppressing and oppressed societies would indeed be willing to undergo a painful process to achieve healing.

I would like to see similar work done in different places in various settings. I would like to see representatives of these nations in some official capacity go through this process. It takes commitment and imagination to set up such a process, but if we bypass an opportunity for emotional breakthroughs, any discussion, apology, compensation, or collaboration for peace will remain superficial.

I would very much like to see young people from both sides—victimized nations and Japan—take interest in and act on the issue of understanding the violence of the past war in order to heal wounds both within and without.

Reflections on the Sino-Japanese War

In 2007, for the seventieth anniversary of the act of sheer brutality that is the Nanjing Tragedy, my Chinese and Japanese colleagues and I organized a conference of over four hundred Chinese and Japanese citizens—"Remembering Nanjing Tragedy"—at the Nanjing Normal University. This was the first such gathering of its kind due to consistent avoidance and denial on the Japanese side. My colleagues who are professors at Japanese universities still bring their students every other year to Nanjing, supported in this effort for some years by the Japanese government. There they study and discuss with Chinese experts and students the record of inhumanity, which is a small but significant effort toward a much needed and genuine Sino-Japanese reconciliation.

Along with forty-one Chinese calligraphers and one American artist, I exhibited my works as part of the conference. This is a script for a short film called Reflection and Remorse: Sino-Japanese War.

Explosions, blood, smoke, and tears. China was attacked in 1937. The killing continued for another eight years. Japan did not declare war against China.

The Japanese emperor mentioned the Sino-Japanese War only when he declared war against the United States and United Kingdom in 1941. He said in his edict, "The government of the Republic of China did not understand the true intention of our empire and made groundless provocations, disturbing the peace in East Asia and eventually forcing us to take military action. This conflict has lasted over four years." This was Japan's official explanation of why its troops were fighting in China.

Japan invaded China. China did not invade Japan. The troops of our country killed thousands upon thousands of soldiers, civilians, and prisoners of war. They raped countless females, including very young girls and very old women. The troops waged chemical and biological warfare and conducted living human experiments.

I was four years old when Japan attacked Nanjing. The more I learn about the magnitude of the massacre the more horrified I become. Nanjing was the worst of many atrocities inflicted by our military all over China. In 1955 the Chinese government announced that the casualties exceeded ten million.

The Chinese troops fought back and eventually won the war. But it is unbearable to think that our soldiers murdered millions. Every Chinese slain had a story. Each one of them lived, loved, and dreamed. It saddens me that we destroyed all these people forever. I am ashamed with all my body and mind.

I am ashamed with all my life. I apologize to all Chinese people for the innumerable atrocities inflicted by our troops. On behalf of all like-minded Japanese I ask your forgiveness. I want my Chinese and Japanese friends to look closely together at our painful past. I want us to collaborate on healing and reconciliation so that we can build everlasting peace between our nations.

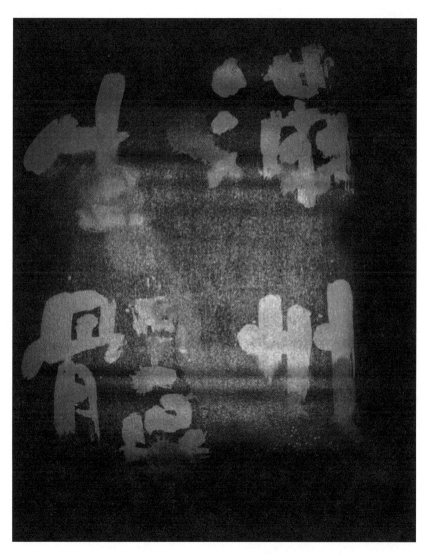

Manchuria Live Human Experiments

Life's Dreams Are Lost

Eternal Remorse

Sino-Japanese War
1937–1945

This poem was set to music by my daughter, Karuna. We visited Nanjing
in September 2012 and Karuna sang this song to some audience members
at the Anti-Japanese War Museum in Nanjing where some of my paintings
on the Sino-Japanese War were exhibited.

A very, very dark path we took
invading the ancestral land of our civilization.
My eternal regret.

A very, very wrong action we took
attacking the friends in our civilization.
My eternal sorrow.

A very, very horrifying action we took
slaughtering millions of people in our civilization.
My eternal guilt.

A very, very devastating action we took
raping thousands and thousands of women in our civilization.
My eternal shame.

A child in Japan of age four to eleven
in the period of unprecedented atrocities—

How can I face it?
How can I atone?
How can I make it up?

Hand

for Karuna

Your hand.
My hand.
 We plant flowers.

Your hand.
My hand.
 We will not shoot guns.

Your hand.
My hand.
 We will not build weapons.

Your hand.
My hand.
 We will not drop bombs.

Your hand.
My hand.
 We write peace songs.

The Yasukuni Shrine Dilemma

National monuments of fallen soldiers, where visiting foreign dignitaries pay respect, exist in many countries. Soldiers killed in action for the nation deserve remembrance and respect even if the war was lost or later came to be regarded as unjust and shameful. Although I am a pacifist, I feel that being considerate to former military personnel does not glorify warriors or support war. Soldiers do not start the wars; they either volunteer or are forced to serve. They should be treated with loving-kindness.

Yasukuni Shrine in Tokyo is dedicated to the spirits of all fallen soldiers in Japan's wars. The shrine used to be the central imperial-military sanctuary of Shintoism, a polytheistic religion in which the dead are often regarded as *kami* or gods. When Japan lost the Pacific War in 1945 and became secular, Shintoism lost its status as the national religion.

The International Military Tribunal for the Far East (Tokyo Trials), convened by General Douglas MacArthur in 1946, convicted twenty-two of Japan's former highest officials of class A crimes for having participated in a joint conspiracy to plan, start, and wage war. Five of them, including General Hideki Tojo, who started the Pacific War as prime minister, were sentenced to death by hanging. General Iwane Matsui, who was the commander of the troops occupying Nanjing, was also sentenced to death for class B or conventional war crimes, including crimes against humanity, having given orders for cruel actions that included murder. There were also class C criminals who had carried out cruel actions by following the orders they were given.

The United States, Great Britain, Australia, the Netherlands, France, the Philippines, and China executed approximately 1,000 individuals and imprisoned 3,400 as class B and C criminals. In addition, the Soviet Union

punished a great number of individuals for war crimes, though the exact number has not been verified.

In October 1947, the spirits of fourteen individuals who were executed or who had expired in prison while being prosecuted as class A criminals were secretly enshrined as martyrs at Yasukuni. Some of those who had been executed for class B and class C crimes had already been enshrined.

Since 1951, when Japan became independent after signing a peace treaty in San Francisco with the United States and other allied nations (except the Soviet Union and China), most prime ministers of Japan have visited the shrine to pay their respects. They often claim they visit "privately," but whatever the head of the national administration does is regarded as official. This action creates international tension because it is seen by neighboring nations, including China and South Korea, as glorifying war or supporting the past action of imperial war. Yet, even though they have known the predictable reactions from overseas, prime ministers still have visited Yasukuni. This may be because of their national pride, but I also suspect that because former soldiers and the families of fallen soldiers are powerful constituencies of electoral districts, political leaders choose to please their supporters despite the price of upsetting neighboring nations. This has been repeated for more than sixty years.

No one has come up with a solution to this long-lasting dilemma. It must be resolved, however, for the sake of peace in East Asia and the Pacific. Here is my humble suggestion: Why shouldn't the head priest of Yasukuni Shrine— Reverend Koji Ogata—hold a rite of de-enshrining all convicted war criminals and then enshrine them instead in Sugamo Shrine or another shrine whose head priest is willing to maintain and console their spirits? (Sugamo Prison is where those accused in the Tokyo Trials were jailed.) It would take just one ceremony to de-enshrine them, and another to enshrine them somewhere else.

I know it can be done, as I was trained as a Shinto priest when I was young. Reverend Ogata can conduct the rites discreetly and announce the result later, which may cause an uproar among those who insist that the Tokyo Trials were an unjust adjudication by victors, but it will be too late; all

the spirits of the convicted would already be residing somewhere other than Yasukuni. I don't think any of these individuals' large-scale crimes can ever be erased, but they already have paid the price, so these spirits of the deceased must be agreeable to having something done that would set a positive course for nations in the future to live together in peace.

Reverend Ogata, do you have the courage to conduct at Yasukuni the rite of de-enshrining the spirits of those who were convicted as war criminals? The matter of Japan's peace with its neighboring nations largely depends upon you.

Peace and War

What can we do when heavy bombing is taking place in another part of the world? Do we simply plead with the governments to stop fighting, insisting that such bombing is not necessary? Is there any other way to stop "ethnic cleansing" than killing those who are engaged in vicious deeds?

These questions kept coming to me as I traveled to a peace conference in The Hague in May 1999. To commemorate the centennial of the very first international peace conference held in that city in May 1899, three conferences had been scheduled there for that month: The United Nations Youth Conference; The Hague Appeal, a conference of eight thousand representatives of nongovernmental organizations; and the World Peace–Inner Peace Conference, which would explore healing world conflicts in relationship to spirituality. I had been invited to create a concluding performance at the World Peace–Inner Peace Conference.

In preparation for the painting performance, I extended my stay at Johanneshof in Germany for a week after conducting an annual Zen calligraphy seminar. Located in the Black Forest, near the Swiss and French borders, Johanneshof is the main practice center of Dharma Sangha Europe.

It was in April when the residents were preparing for an intensive meditation retreat of about fifty people. Getting up at 4:30 every morning, I joined the communal meditation and service, then participated in a semiformal vegetarian breakfast, using bowls and chopsticks. There was a marvelously serene atmosphere in this large monastery building, which was similar in appearance to neighboring farmhouses. The residents were, as always, kind and loving. I was happy to be in a place where some of my Japanese-style calligraphic works were hanging on the walls. I also had had the honor of

writing the sign above the front door on a wooden board with natural edges that read *Genrin-ji* (Black Forest Monastery), as well as the sign for the Zen meditation hall, *Funi* (Not Two).

One of my tasks at Johanneshof was to get three panels of canvas cut and made into a large scroll (fourteen by fifteen feet). Another task was to get the wooden part of an unusually shaped brush made. The front of the "box" of the brush that would contain the "bristle" would be twenty-seven by twenty-three inches. Four horizontal handles would be added to the sides so that four children could draw a circle together. With the help of Götz, the work leader of the monastery, I got a large roll of primed canvas delivered and had a brush built by a nearby woodworker. The brush was designed so that it could be dismantled before shipping.

The war in Yugoslavia had been posing a particularly hard problem for peace activists. The policy of its government and military forces to systematically capture, kill, rape, and expel hundreds of thousands of ethnic Albanians in Kosovo was demonic. In most previous cases, such policies by totalitarian governments had been regarded as internal affairs; the international community had not intervened to force them to stop. The intention of the United Nations and NATO in trying to stop this atrocity as their moral responsibility was admirable. Furthermore, this precedent would make it more difficult for other nations to undertake such brutal actions. My fundamental question, however, was whether the political leaders of the NATO nations had pushed their diplomatic means as far as possible before they decided to attack former Yugoslavia. I had serious doubts about this.

NATO's fierce air strike on the Balkans had been going on for several weeks. Even in this quiet monastery the residents talked about the increasing number of civilian casualties and a mistaken bombing of the Chinese embassy in Belgrade. The game of massive destruction reminded me of how little one could do in the face of military aggressions. War is a dramatic and news-making event. Villains and heroes engage in battles, causing tragedy for millions of families, changing the map of the region, marking an era, and creating history. On the other hand are actions for peace accumulated in a series of small steps by ordinary individuals. What is yet possible is to build communities, network, and try to change the consciousness of people at pres-

ent and in the future. The effect of contemplation, collaboration, and education for peace is often subtle and goes unnoticed.

Violence creates more violence. War destroys the health and happiness of most people who are touched by it. Although military intervention may seem like a simple solution to difficult problems, we must find wiser ways to increase the sustainability of society as a whole. NATO must have spent billions of dollars in its first several weeks of bombing alone. The World Bank estimates that the cost of postwar Balkan reconstruction was $100 billion (the *Economist*, May 29, 1999). Budgets to promote human health and well-being are microscopic in comparison. For instance, the total worldwide cost of providing women in developing countries with reproductive health care per year is $17 billion.

I was aware that a number of peace proposals by nongovernmental organizations would be discussed at The Hague Appeal Conference, but I thought that many people in the world should present their own ideas. So I decided to write a proposal to be distributed at another peace conference I was going to attend. Friends in Johanneshof let me use a computer in their office. I wrote:

Can we stop "ethnic cleansing" and other kinds of large-scale violence without the use of military forces? If so, how? Here is a proposal to national governments and the United Nations for forming groups of International Peace Advisers as a way to prevent war.

With the understanding that every conflict is unique and that no single individual or government may be able to come up with a solution to stop military atrocities, a group of specialists will be called in to work on each conflict. Specialists would include those who have firsthand knowledge of the history, culture, religion, politics, and psychology of the oppressors and of people who live in the region in conflict. Specialists in international affairs and economics, as well as those in conflict resolution, may also be asked to join the advisory group.

Such a group may be formed by a national government and/or by the United Nations itself. The mission of the International Peace

Advisors is to identify the best possible solutions for stopping atrocities without the use of armed forces. They may request help from other experts and suggestions from the public. The advisors should not represent any government, corporation, or other interest group. Their sole task is to find peaceful and practical solutions to end violence.

The government or UN should commit itself to following recommendations of the International Peace Advisors and to refraining from military action until the recommended means have been fully pursued. The International Peace Advisors may advise the national government or the United Nations to further the effort to understand the positions of conflicting parties rather than telling them what to do. The advisors may also find a way to help the oppressors put an end to their cruel actions instead of threatening or punishing them.

The problem of large-scale violence, including "ethnic cleansing," often has confusing and complex elements, and there is no simple solution. Solving such problems without going to war requires a powerful will and unprecedented commitment. But we must stop violence nonviolently, whatever it takes.

Two days before the conference I barely managed to transport the disassembled "brush" and the rolled-up canvas from Basel to Amsterdam. Wouter Schopman, owner of a beautiful hotel and a new float-tank center (for relaxation and healing) in the heart of the city, welcomed me warmly. He was the friend who, a year before, had thought of bringing me to the conference, and who had eventually become the sponsor of the painting performance project. Elisabeth van Deurzen, a friend of Wouter's, who had been helping to organize the conference, took me to the International School of Amsterdam to deliver the brush that was to be decorated by students.

On the first day of the World Peace–Inner Peace Conference, Wouter, Elisabeth, and I drove together from Amsterdam to the convention center located amid tulip fields near the North Sea. Over three hundred participants assembled in a large circular auditorium overlooked by balconies. Opening

music and addresses by "wisdom elders" were followed by remarks by Rodrigo Carazo, former president of the Republic of Costa Rica, who said he had come from the center of the world. Given that his country had had no army for half a century, his words were very refreshing and memorable. Robert Muller, chancellor of the United Nations University for Peace in Costa Rica and former assistant-secretary general of the United Nations, gave an inspiring speech on how he had worked as a peacemaker throughout his life and learned spirituality through his collaboration with some of the founding leaders of the United Nations.

The three days of the conference were marked by three major themes: healing the self, the earth, and others; peace with soil, soul, and society; and a call for the great work of building cultures of peace and justice. The meetings were very well organized, and the presentations were excellent. Deep connections were made among participants. I felt that the future effects of this gathering were unfathomable. I was able to speak briefly on the Ten Millennium Future Project and to present my proposal for the concept of International Peace Advisers.

On the morning of the last day, Wouter and I, with our video crew Nick and Eleanor, managed to tape the canvas together and then draw pencil lines to mark the outer and inner borders of the circle. I installed strips of white felt to function as a bristle for the box-shaped wooden brush, on which the schoolchildren had painted brilliantly colored images of birds, trees, and flowers. In the afternoon, eighty students from the International School, dressed in clothes of their ethnic heritage, arrived in one of the conference rooms. Eight had been chosen to do the painting performance. Four of them, ages eight to twelve, were to pour the colored paint. Four others were to paint with the brush.

In the chaos of chattering children, I had five minutes to explain the concept and process of the performance. We quickly conducted a rehearsal with a dry brush on the canvas. I asked the performers to be careful not to step on the paint poured on the canvas, and told them that the most important thing was to relax and enjoy what they were going to do. Then their teacher said they had to go backstage to get ready for the singing that would precede the painting performance.

As soon as the chorus had completed its performance, a few people helped me carry the canvas and unroll it at the center of the round auditorium. I explained to the audience the meaning of a circle in different spiritual traditions—inner peace, freedom, and wholeness—as well as the significance of the circle the children were going to create—world peace and peace on and with the earth.

Then I showed the children how to squeeze out colors from the plastic squeeze bottles. On one-half of the circle two children poured green paint, and on the opposite side two others poured blue paint. Two girls and two boys then brought the joyful-looking brush onto the canvas and started painting. Now that the brush was in their hands, I stood back and watched. They drew the circle slowly and carefully. On finishing their stroke, they lifted the heavy brush and passed it to other children, who worked hard to place the brush properly in its stand.

The *Circle of Peace* these children painted was nearly perfect in form, yet alive and spontaneous. The paint was still wet and shiny. In the limited time for preparation and under pressure, the performers did a magnificent job. The presence of eighty beautiful children from different parts of the world added much love to the conference. They represented the reason we were all there. It was every participant's hope, I am sure, that some of these children and their friends would carry on the work of our generation to the next.

Gift of Gifts

for Ko

My son, my love,
wondrous is your gift.
Your peaceful mind
is so precious to me.

My son, my love,
wondrous is your gift.
Your march for peace
is so precious to me.

My son, my love,
wondrous is your gift.
Your faith in nonviolence
is so precious to me.

My son, my love,
wondrous is your gift.
Your smile in peace
is so precious to me.

Love in Syria

Shall we see miracles of peace in the Middle East? The chances of sustainable peace may appear extremely slim, but what are Middle Eastern peoples' hopes and visions? How can an outsider like myself listen to their voices and step beyond my own ignorance and feelings of helplessness when it comes to the crisis?

These are questions I asked myself on the way to Syria in May of 2002. The urgency of these questions led me to Damascus on the Interfaith Pilgrimage of Peace, despite a US State Department travel advisory and friends' concern for my safety, due to the tension that erupted after the Israeli seizure of a church in Bethlehem.

I arrived in Damascus at about 1:00 a.m. on May 7. A taxi driver was waiting to take me to Hotel Al Majed. In the morning, I met my fellow pilgrims—ten women and ten men from five different countries. They had been in the city for two days, sightseeing and talking with people on the streets, including students protesting the recently intensified Israeli military actions against Palestinians.

Damascus itself has been a thriving city since the dawn of civilization. From the hotel window I could see hundreds of gray concrete houses with small windows spreading up a bare mountain with brown rocks and sand. This is the city to which the Roman soldier Saul was heading, on his way to persecute Christians, when he saw the ghost of Jesus. Receiving his call, Saul became Paul and helped build a great Christian community.

The organizers, Rabia Roberts and Elias Amidon of the Interfaith Peacemaking Initiatives in Boulder, Colorado, were the only ones I had previously known. Rabia is a Buddhist teacher; her husband Elias is a Sufi teacher. Although I had never visited this part of the Middle East, I had been asked to

be a "guide" along with them. Elias explained to me that we had only an hour and a half to discuss getting materials for the "Circle of Peace" we planned to create here. My last e-mail communication to Elias had described the cloth we would need for the "flag" that would hang outside the desert monastery where we were to hold a retreat. I wanted the artwork to be large enough to create a strong visual impact.

That morning in Damascus the two of us quickly agreed upon a plan and hopped in a cab bound for the busy shopping quarters near the Umayyad, the city's central mosque. At a small store we bought raw cotton, enough to make a flag consisting of five panels that would eventually come together to be fifteen feet wide and eighteen feet high. In another shop we found cloth dyed blue, green, orange, and gold—colors that in my mind would represent peace, healing, and transformation. We walked down the alley to another shop, where we bought a spool of rope. We purchased 225 feet of rope for the equivalent of five US dollars.

A minibus took us north, less than an hour from the city, through a dry and sparsely populated region to the nunnery of Seinayya, where an image of the Virgin Mary purportedly painted by Saint Luke is enshrined in an underground grotto. On the wall, there were a number of icons that had been blackened by incense and candle smoke, as well as the hands of devout pilgrims who had come seeking miracles. In the nave, the central image of Mary was hidden behind small icons and objects. We sat in silence. A nun blessed us one by one, anointing our foreheads with sacred oil.

The Sufi tekke of Sheikh Nazim Qubrusi overlooked a desert valley not far from the Virgin Mary's nunnery. An English speaker, the sheikh attracted devotees from Western as well as Arab countries. While he was napping, our group of pilgrims joined up with about thirty of his followers—men and women waiting in separate rooms. Several toots of a whistle and the laughter of women indicated that the master was ready for his audience.

A short man in his eighties, Sheikh Nazim, wearing a bright green turban and shawl, sat on a sofa in total relaxation. He regaled us with a steady stream of jokes and puns, even while making the serious point that being a servant is good, but being a slave is not. Someone asked him about the practice of zikr, or total uncompromised remembrance of the divine name.

He took up his beads and started counting, "Dollar, dollar, dollar . . . ," "Euro, euro, euro. . . ." Everyone burst out laughing. He looked at me and said, "Yen, yen, yen. . . ." I was struck by his gentle but right-to-the-point criticism of materialism.

One of the foreign devotees cried: "Initiation, please!" Many people swarmed around him and touched his body. Sheikh Nazim invited me to hold his right hand while he gave a blessing. That touched upon my deep yearning to be connected to the Muslim faith.

Our bus continued north, deeper into a desert of rocks, sand, and hills. The distance to the Lebanon border in the west narrowed. At dusk, we pilgrims climbed up from the foot of a steep cliff to the monastery of Deir Mar Musa el-Habashi, a compound of stone buildings perched on a hillside, founded by Saint Musa Abyssinian (Saint Moses of Ethiopia) in the sixth century. We were greeted by the abbot, Father Paolo Dall'Oglio, a man in his early fifties with short black hair, a robust body, and a wide chin covered with a short beard. He wore glasses and a monk's pale-gray work clothes.

Monastic life was simple there: The grounds and rooms were lit by dim electric lamps. In the newly built guesthouse, ten minutes away from the main building beyond a steel bridge, were Western and Asian-style flush toilets and a kitchen with filtered water.

Goat and chicken farming seemed to make their life sustainable. They kept dozens of goats on the ground floor of the residents' building, and set some of them free to graze on the sparse grasses of the distant hillsides. Sometimes we heard a novice shouting "Ho," throwing stones to drive them home along the narrow paths. At every meal we were served homemade goat cheese and yogurt, along with pickled olives and pita bread. Fresh tomatoes, lettuce, and zucchini were brought down from the back mountain by trolley. Chicken or goat meat marked a feast. We ate on a terrace unless a sandstorm came up.

Father Paolo explained that the commitment to the monastery was prayer, manual labor, and hospitality. They did not charge visitors for staying in guest quarters, as long as they participated in the housework.

After settling into guest quarters on the first evening, we bowed through low doorways carved in the rock to enter the main building and join the mass.

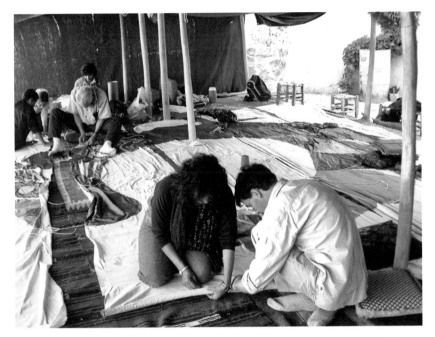

Creating *Circle of Peace*

The chapel is a ruin of an eleventh-century sanctuary, with arches and square pillars inside. A wooden chancel built on an old stone base encloses the central altar. On the other end of the chapel was a huge and well-preserved Byzantine-style fresco of groups of icons and individuals gathered for the Last Judgment. In this somber, candlelit atmosphere, everyone was seated on the floor, while the liturgy was conducted in Arabic.

Father Paolo taught us the chant *Allah husm'hus salaam*, which means "Allah, whose name is peace." I had always thought that "Allah" was exclusively used by Muslims, but since it means God in Arabic, it is also used by Arabic-speaking Christians.

In this simple and ancient setting, I received the Holy Sacrament. To be a Muslim and Christian in one day confirmed my practice as an interfaith pilgrim.

On Wednesday morning, the second day at the monastery, we held a gathering in an underground grotto, called Sleeper's Cave. Father Paolo asked me to start the meeting with a blessing. So, I offered an ancient chant from Shintoism, the indigenous religion of Japan. It goes: *hito futa mi yo itsu muyu nana ya kokono tari momo chi yorozu*, which can be translated as "One, two, three, four, five, six, seven, eight, night, ten, one hundred, one thousand, and ten thousand." I explained that these numbers can be seen as our hope that humanity may live another ten thousand years.

This chant seemed an ironic preface to Father Paolo's briefing on the theological importance of Jerusalem for the three Abrahamic religions. For Jews, it is their homeland, the site of their historical Temple. For Christians and Muslims it is the apocalyptic city of the Judgment Day. Their scriptures prophesy that at the end of the world the Messiah will arrive in Jerusalem. Christianity and Islam established Rome and Mecca respectively as their sacred cities until the apocalyptic moment when they inhabit Jerusalem.

I asked Father Paolo about the relationship between his belief in apocalypse and my hope for the long-term survival of humanity. He explained that the Messiah is seen as returning in every instant. I found his view in amazing coincidence with the Buddhist view that every moment contains birth and death, including the possibility of life as a dweller in hell, or as a hungry ghost, animal, human, or celestial being.

Father Paolo has been a leading advocate of interreligious communion in the Jesuit Order. That evening, after an hour of silent meditation, he asked me to begin the mass with the Shinto chant. I was moved by his openness to other faiths. Perhaps this was the first time a Shinto chant had been recited at a Catholic mass in the Islamic world. During the mass, he shared bad news: A Palestinian suicide bomber had killed fifteen people and injured forty. Israel's prime minister Sharon had ended his meeting at the White House and canceled further meetings in the United States to head back and "prepare for revenge."

On Thursday morning, we unfolded the five cotton strips on the floor spread with carpets in the tented terrace of the main monastery building. I asked some of the pilgrims to stand on the cloths and form a human circle. With a pen, I drew the outer and inner borders of a wide circle. People were then asked to cut up colored cloths and sew them onto their parts of the circle, in groups or individually. They were free to choose colors and designs for their sections without considering what their neighbors were doing or the design as a whole. Some of the fabric was sewn with one side loose to make "banners on the banner." Everyone in our group participated in the sewing. Some visitors to the monastery also helped. After a few short hours of cutting and sewing, the "Circle of Peace" took shape.

Early Friday morning we left for a day trip to Damascus. We met with Sheikh Salah el-Din Kufato, director of the Abu n-Noor Islamic Foundation, a large educational and charitable organization of Sufism—Islam's majority faith in Syria.

He led us to the mosque, where we saw an old man seated on a high platform, the grand mufti Sheikh Ahmad Kuftaro, Syria's highest Islamic cleric. About four thousand men sitting on the huge floor were waiting for the men in our pilgrimage group to find chairs at one side of the grand mufti. Our female co-travelers were seated in the window-sheltered balconies. We were given headphones to hear the mufti's talk translated into English.

Although his physical condition was checked periodically by someone who seemed to be a physician, the grand mufti spoke clearly for a long time. I was moved when he said that he himself was a Christian. According to his interpretation of the Koran, a good Muslim must be a good Christian, as the

Holy Book regards Jesus as one of the prophets. He explained how religious leaders were responsible for bringing peace but had been failing to do so. And he admitted that he himself had failed. I found him a person of true wisdom and humility.

Religious tolerance and the coexistence of different faiths seem to be embedded in the history of this country. The Umayyad Mosque in Damascus was originally an Aramaean temple for worshipping Hadad, then became a temple of the Greek god Zeus, the Roman Jupiter, and Christ. After Christians and Muslims worshipped together for some years, the Muslims purchased the site from the Christians and allowed them to build a large cathedral nearby. The tomb of John the Baptist is still enshrined in the mosque. We pilgrims had come to Syria for inspiration because of its centuries-long Muslim-Christian coexistence.

After the grand mufti's sermon, Elias was asked to address the audience. He offered a long and passionate Sufi prayer by heart, which was simultaneously translated into Arabic. I was proud of him. Elias and half of our pilgrims were members of the Sufi Way International, which regards their faith as non-Islamic, although most of their songs and prayers are based on Islamic tradition. These Sufis seemed to be a perfect bridge between the Islamic world and the predominantly Judeo-Christian world of the West.

That evening we visited the Church of Our Lady of Damascus, a Syrian Orthodox church. We met with Dr. Isaam el-Zaiim, Syria's minister of industry, and Dr. Mohammed Shukri, a professor of law who had worked at the United Nations on terrorism issues. Both of them spoke fluent English. Father Elias Zehlawi, abbot of the church, spoke French.

Their briefings on the history of the conflict with Israel and the current situation indicated the near impossibility of hope for a tentative peace agreement. They explained that the proposed Palestinian state, consisting of only a small portion of territory captured and occupied by Israel in 1948 and 1967, would not satisfy the Arab majority. Even if a peace treaty were concluded, a ceasefire might not last long.

Father Paolo, who facilitated the meeting, pointed to me to address the initial questions. I asked, "What are your best dreams, your hopes, and visions regarding the conflict with Israel and the future of your country?"

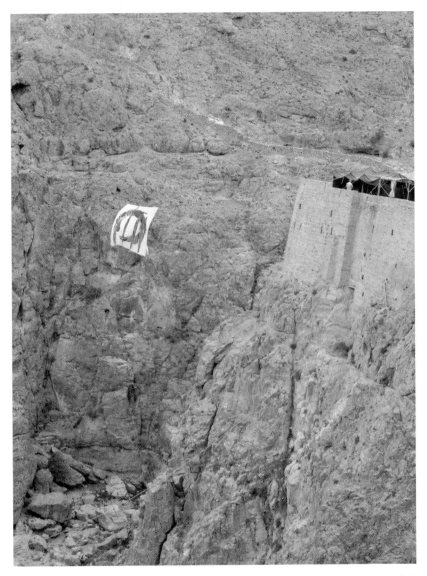

Circle of Peace, installed

These thoughtful gentlemen responded with a further analysis of the difficulties they were facing. One of them said, "We will not give even an inch of our land they are occupying. We may not be able to achieve victory right away, but we will persevere."

So I asked again, "Do you have any ideas about how to change Israeli public opinion so that you can achieve peace in a way that furthers justice for your side and that allows you to accept their justice?" Perhaps my question was naive or out of line. I did not receive an immediate answer, but I hoped that this question would remain in the minds of some of those present. As I was a short-term visitor and not an expert, I spoke humbly. But I truly believe the only way the Arab world can achieve what they want is to appeal to the peace-loving nature and the sense of common justice of Jews around the world, including Israelis. Only by disavowing violence in order to build trust can they hope to transform Israeli public opinion, and move toward a comprehensive peace agreement. (The same is true with Israel in regard to the Arab world.)

Many questions and answers followed. Apparently Israel does not exist on maps, other than those marked "Occupied Palestine," in the Arab world. Someone commented that the potential for Israel to withdraw from the West Bank is as unlikely as the United States giving back all its land to Native Americans. What a daunting task it is for those working to achieve peace in that region!

In Israel and its occupied land, suicide bombings cause horrible damage to civilians. This could be seen as a desperate resistance against decades of oppression, torture, and violence against Palestinian civilians. My fear, however, is that these bombings may be only a prelude to wider and more organized violence. As groups become more desperate and more organized, an entire city could be blown up or contaminated by a dirty bomb at the hands of a few extremists.

Access to nuclear and biological technologies is public knowledge. As a campaigner with Plutonium Free Future, I have talked to many scientists and know that crude nuclear bombs are easy to build. Substances needed for such a device can be smuggled across borders. I fear a new world war, which may not be a classic war between nations but a "war within"—fighting with

individuals who have distributed ultra-destructive substances throughout a society. If just one city were to be wiped out, there would be one fierce reaction after another, thus fulfilling the prophecy of the apocalypse centered around Jerusalem.

At the Church of Our Lady of Damascus a TV crew interviewed Elias, Rabia, and me. My fellow guides talked about the pilgrimage. I talked about the art project "Circle of Peace." The interviewer changed the subject abruptly and asked me, "What do you think about Israeli forces causing great violence in Palestine? What do you think of them seizing a church in Bethlehem?" This was a tough question to be directed to a visitor who wanted to be friendly to all sides. I felt I had no right to say anything sensitive that might represent my fellow pilgrims. So I followed a voice from deep within, which was as much a surprise to myself as to anybody: "The more we listen to our friends in Syria, the more we realize the near impossibility of achieving peace with justice. But I believe there will be breakthroughs. In fact breakthrough may be happening right now without us noticing it." This is what I learned during efforts to reverse the nuclear arms race between superpowers: from impossibility comes possibility.

On Saturday morning, we tied the cotton panels of *Circle of Peace* onto a long rope. We found an old hose in the monastery, and cut it into five pieces, stuffing each with sand. We sewed the pieces to the bottom of the artwork as weights.

In the afternoon, two brave mountain climbers—Patrick Bryden from England and Elias—went down from the terrace to the bottom of the three-story cloister, crossed a steel bridge at its side, and brought up one end of the rope on the other side of the gorge. They climbed, inching up a rocky hillside above a sheer drop, and found a spot where they could secure the end of the rope.

With the sound of handheld drums and the increasingly ecstatic repetition of *Allah husm'hus salaam*, our banner was pulled toward the center of the space in the gully. Gradually it unfolded and revealed its entire body. The huge appliqué looked tiny in the middle of the desert gorge. But when the panels caught the wind like sails and started swinging and flapping, with its bright patches of colors breathing and bellowing, its presence was joyfully

expanded. Brother Jens, one of the few monastic residents, was waiting on the other side of the monastery, capturing magnificent pictures and footage with his photo and video cameras: *Circle of Peace* united with the forces of nature.

On Sunday, dozens of visitors—both Syrian and European—arrived for a day visit. We invited them to join us in making prayer flags for peace, laying out paint, magic markers, and small pieces of cloth. Father Paolo jokingly suggested that we offer prayers for rain. I said that I would paint a dragon, though I had never done so. We created about one hundred flags. One Arabic prayer said, "We will not be thrown into the garbage any more." Another said, "Peace with victory." How clear and how sad their wishes were!

We had half a day to prepare for the creation of another circle, to be painted inside the chapel. As *Circle of Peace* was already hanging outside, I wanted to go further on that theme. While cutting out two pieces from the leftover cotton for a painting six feet square, I wondered what might actually call forth everlasting peace in the midst of all that desperation.

I assembled a brush by tying shreds of cotton around a wooden stick. Elias had brought some tubes of acrylic paint from Athens. I made two squeeze bottles by poking holes in the caps of drinking-water bottles, which I filled with a mixture of paint and water.

The pilgrims met that evening in the chapel. Lowell Brook, an artist from Berkeley, California, first offered her prayer for creativity and freedom from fear of all kinds. Then she read my prayer:

> O Allah whose name is Peace!
> We dedicate a circle called "Miracles of Peace" to you and to
> all beings.
> Once the pope wanted to know who the greatest artist of his
> time was.
> So he asked all artists to submit their works.
> Giotto was one of those who submitted his paintings.
> And he was determined to be the greatest.
> His artwork was a circle done by free hand—a perfect circle, heart
> of Sacred Geometry.

Perhaps he had represented the perfect grace of God more directly
than any of the other artists.

A circle represents enlightenment in the Zen Buddhist tradition.

A circle belongs to all people.

Our circle painted here at this Monastery of Saint Moses the
Abyssinian in a Syrian desert represents peace for our
children and their children.

It represents peace with our Mother Earth.

O Allah whose name is Peace!

May we all continue to be workers of peace!

May we help stop violence nonviolently!

May we help humanity to sustain all being!

May we help humanity to sustain the environment!

May miracles of peace take place in the Holy Land!

May miracles of peace take place in all regions of the world!

Then, Meindert van de Vries, a physician of Jewish descent from the Netherlands, started playing the violin. While the sweet and devotional tune was going on, I spread green paint in a half circle on the left-hand side and blue paint on the right. Using the squeeze bottles and pouring paint back and forth, I could lay out a nearly perfect circle. I took up the brush and swept through the paint with one slow stroke. Then we all sang with the drum and harmonium.

On Monday we attached the prayer flags to a string and suspended them as Tibetans do, from the main building to another, across from the large banner. The next day, the sky was covered with dark clouds. Thunder roared, and rain started pouring. We had been told that this would be rare in the desert at this time of year. Some of us got soaking wet. We had to push up the tent with a stick to release the trapped water. Whether my clumsy painting of a dragon worked or not, it was certainly a mistake to have wished for rain without having brought umbrellas to the desert.

Meanwhile, from time to time our group held a "council"—sitting in a circle with each person speaking from the heart, while others listened deeply

without commenting. In this way we deepened bonds with each other. In the afternoons we had dharma talks in one of the hermit's caves. Elias explained the Sufi practice of zikr or remembrance. Elmer from the Netherlands shared stories about Ibn 'Arabi, one of the most influential Islamic thinkers of the twelfth to thirteenth centuries C.E. Aisha from England led us in a psychotherapeutic experiment of seeing self in other. Rabia, a former professor of religious studies, offered a grand historical view of feminine spirituality.

In the underground "Sleeper's Cave," Ed Bacon, rector of a large Episcopal church in Los Angeles, reported on his recent visit to Israel and Palestine. He told stories of extraordinary suffering among people he had interviewed, and of movements for peace on both sides.

My presentation was about using aikido as a spiritual practice for transforming social situations. In order to illustrate the flow and merging of forces, I asked Brother Jens, who had practiced the art for fifteen years, to be the receiver of my "throw." I talked about the concept of "protecting the enemy" taught by my teacher Morihei Ueshiba, a Shinto priest and the founder of aikido. He had said, "True victory comes only when you let the other side win." If we had any way to bring breakthroughs to the Middle East, this might be one of them.

I also talked about the Buddhist concept of selflessness that enables one to become free of self-identity and self-possession. The Vietnamese Zen teacher Thich Nhat Hanh suggests that a famous line from the *Heart Sutra*— "Form is emptiness"—can be interpreted as "all forms are interconnected." To me, it can also be interpreted as "form is without boundary." Only by going beyond the shell of our own self can we see other people's needs and feel less anxious about losing our privileges and possessions. The Dalai Lama's praying for the Chinese who have killed thousands of his people is an inspiring example of this teaching of boundlessness.

On Tuesday evening we held an interfaith service. Monks, nuns, and the novices of the monastery dressed informally and sat with the pilgrims and visitors from Germany and France on the chapel floor. Father Ed sat in front of the altar. The artwork *Miracles of Peace* was laid out in the center. On this painting, Bibles and the Koran were placed on separate book racks, surrounded by lit candles.

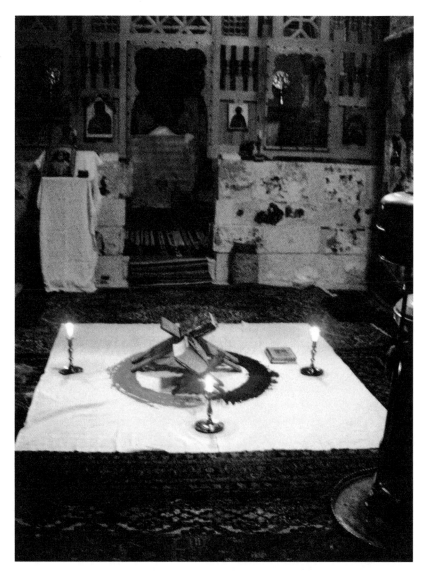

Altar ready for a mass with *Miracles of Peace*

Taking turns one by one, we called out names of God in different languages—love, truth, justice, Mother Earth, peace. We read, sang, and chanted from Catholic, Orthodox, Protestant, Episcopal, Muslim, Sufi, Jewish, New Age, and Shinto traditions. In this ancient temple of God in the desert, in the dark chapel, we shared a pita bread, which represented the sacrament of all faiths.

Father Ed asked me to conclude the ceremony with a prayer for a ten-millennium future. I wished I had one. Instead, I chanted the mantra of the *Prajna Paramita Heart Sutra* ("The Sutra of the Heart of Realizing Wisdom Beyond Wisdom") and my personal translation: *"Gaté gaté paragaté parasamgaté bodhi svaha!* Arriving, arriving, arriving all the way, arriving all the way together: Awakening! Joy!"

Wednesday was our day to leave the monastery. We had our last council meeting in the balcony tent with Father Paolo. Rabia and Elias reported on a project called the Global Nonviolent Peace Corps. They were helping groups in different parts of the world set up regional headquarters. In fact they were on their way back to Jordan to meet with high-ranking political leaders about the Nonviolent Peace Corps. Many of us offered to help with this formidable task.

I asked Lowell to read the questions I had been working on, as I am not a good reader. In my cave-like guest room I had been contemplating questions that might in the future lead the region from continuous fighting and catastrophe toward everlasting peace.

THE EIGHT QUESTIONS

All those who seek comprehensive and everlasting peace in the Middle East, please momentarily set aside your experience of facts, beliefs, and feelings. Listen to the deepest part of your heart and answer the following questions. As soon as you have answered them unanimously, breakthroughs carrying miracles of peace will take place!

> Do you want freedom from the fear of war?
>
> Do you want freedom from relying on military forces to maintain security?

Do you want freedom from the desire to annihilate people on
the other side?

Do you want freedom from reacting to violence with violence?

Do you want freedom from political segregation by race or
faith?

Do you want freedom from economic inequity based on race
or faith?

Do you want freedom from the need to occupy lands other than
your homeland?

Do you want freedom from the need for one nation to maintain
sovereignty over Jerusalem?

It was hard to say goodbye to Father Paolo and residents of the monastery.
I felt so much love and affinity toward them. We pilgrims started to descend
the cliff. The broad belt of barren land ahead of us angled toward shades of
evening.

*Armed uprisings against the tyranny of President Bashar al-Assad started in
2011. While the domestic conflict escalated and terrorist dominance expanded,
millons of Syrians escaped from their own country and became refugees—if they
were not killed or drowned while trying to cross the sea. Father Paolo was expelled
from Syria for supporting the protestors in June of 2012. He went back to the
country for mediation but soon disappeared. Many of his friends, including my-
self, prayed for his safety. In 2013 an international organization reported that he
had been killed. However, according to a news site called* The Daily Beast, *on July
28, 2015, Pope Francis pleaded for his release. That must mean that Father Paolo
Dall'Oglio is still alive. Our prayer continues.*

Ah Nagasaki

Jan Chozen Bays Roshi, co-abbot of the Great Vow Monastery in Clatskanie, Oregon, was born on August 9, 1945—the very day of the atom bombing of Nagasaki. She asked me to assist her in her project to bring thirty thousand painted images—as many as those who were killed in Hiroshima and Nagasaki—of Jizo Bodhisattva, a guardian deity of suffering beings and the dead, to those cities for her sixtieth birthday. Two years prior to that, Chozen, her husband, Hogen, and I visited the city of Nagasaki, where I conceived a bilingual choral symphony, "Ah Nagasaki." I asked Robert Kyr, who had set some of my peace poems to music, if he would compose it. He said yes and we collaborated on the text; the music became his tenth symphony. The text and score were dedicated to the citizens of Nagasaki on the sixtieth anniversary of the bombing in 2005. This symphony was performed in St. Paul, Minnesota, a sister city of Nagasaki, in 2008.

AH NAGASAKI: ASHES INTO LIGHT
Part I: Light into Ashes

CHANTER:
Namu Amida Butsu.

GIRL SOPRANO:
Koko wa Nagasaki.
I am in Nagasaki.

BOY SOPRANO:
I am in my favorite city.

GIRL SOPRANO:

Itoshii machi.
I am in my favorite city.

BARITONE:

Another hot day. Still at war, always war.

TENOR:

Kyō mo, atsui hi ni naru. Sensō no, mattadanaka da. Tada, sore dake da.
Another hot day. Still at war, always war.

ALTO:

Another busy day. War and only war. Nothing else.

SOPRANO:

Kyō mo, isogashii darō. Sensō, soshite sensō. Tada, sore dake da.
Another busy day. War and only war. Nothing else.

CHANTER:

Namu Amida.

WOMEN'S CHORUS:

Kono yo no tsumi wo nozoku kami no hitsuji yo,
Agnus Dei qui tollis peccata mundi, Lamb of God who takes away the sins
 of the world.
Warera wo awaremi tamae.
Miserere nobis.
Have mercy on us.

BOY SOPRANO, THEN CHILDREN'S CHORUS:

Ring around the rosie,
Pocket full of posies,
Ashes, ashes,
We all fall down.

Kata, kata, kata; Pata, pata, pata; Toko, toko, toko.

WOMEN'S CHORUS:

Kono yo no tsumi wo nozoku kami no hitsuji yo,

Agnus Dei qui tollis peccata mundi, Lamb of God who takes away the
sins of the world.

Dona nobis pacem. Grant us peace.

A blinding light, then the sounds of the explosion . . . and eventually:

Witness Cycle

SUNG BY INDIVIDUALS FROM THE CHORUS:

Karadajū ga moe te iru.
Fire—I am burning.

Tsubusa re ta. Itai.
I am crushed . . . my legs . . . my legs.

Akachan wa, doko?
My baby—Where is my child?

Me ga mie nai. Iki ga deki nai.
I can't see . . . can't breathe . . .

Mizu. Mizu ga hoshii.
Water, I need water.

Okāsan. Okāsan.
Mother . . . mother.

Otōsan. Otōsan.
Father . . . father

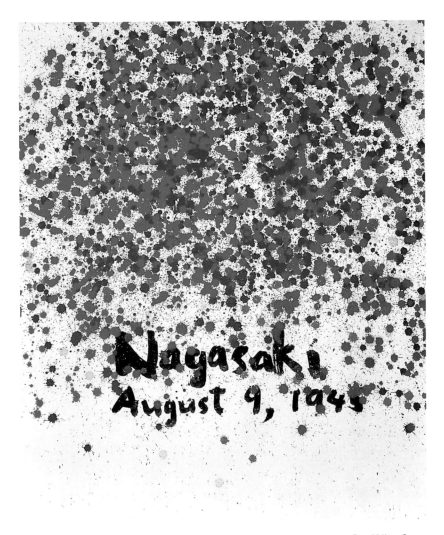

Nagasaki
August 9, 1945

One Million Suns

Musuko yo. Musume yo.
My son . . . my daughter

Obāsan. Ojiisan.
Grandmother . . . grandfather

Dōkyūsei wa doko. Asuko da. Haidasō to shi te iru.
Where are my friends? . . . There: trying to escape.

Mō shinu n da. Anata tachi wo nokoshi te.
I am dying; my love . . . my love.

Ō, Iesu sama, Iesu sama.
O Jesus, O Jesus!

Kan'non sama, otasuke kudasai.
Avalokiteshvara, help me!

Namu Amida Butsu, dōzo otasuke kudasai.
Amitabha Buddha! Save me!

Kami sama, Kami sama, tasuke te kudasai.
Gods, gods, help me!

Onegai shi masu, Mariya sama.
Help me, help me, Mother Mary!

Ō, Ojizō sama. Ojizō sama.
O sacred Jizo, Jizo!

Kami sama, Kami sama, dōshi te watashi wo misuteru no desu ka?
O my God, my God: Why have you forsaken me?

Witness I

SOLOS:

Watashi wa omoidasu.
This is how I remember it:

Machi no oto ga kikoe ru. Hikōki no kasukana hibiki.
City sounds. A faint sound of airplanes.

Totsuzen, hyakuman no taiyō da.
Suddenly, one million suns!

Me ga mie nai. Mimi ga kikoe nai.
Blinding . . . deafening . . .

Soshite, makkurani naru.
Then darkness.

Ankoku to chimmoku.
Darkness and stillness.

Osoroshii chimmoku.
Dead silence.

Witness II

SOLOS:

Tsuyoi bakufū ga, watashi wo uchitaosu.
A strong blast knocked me down.

Yakekogasu netsu no nami ga, watashi no ue wo tōrinukeru.
Then a wave of heat rolled over me.

Tatemono ga ochi te kuru. Shitajiki ni naru.
I was buried under debris.

Sukui wo matsu.
Waiting for help . . .

Makkura na tokoro de matsu.
Waiting in darkness.

Matsu . . .
Waiting . . .

Witness III

SOLOS:

Watashi no tomodachi, Watashi no kazoku . . .
My friends, my family . . .

Doko mo kamo ga, inochi. Soshite, kyūni, dare mo, inaku naru.
Life everywhere . . . then suddenly: nothing.

Okiagat te, atari wo mimawasu.
I sat up and looked around.

Tada mieru no wa, futatsu mittsu no tatemono no honegumi dake da.
The only thing that I saw: Skeletons . . . skeletons of a few buildings . . .

Hokani wa, nani mo tat te i nai.
Nothing else was left.

Hontōni, nani mo tat te i nai.
No, nothing else.

Isshun de, zemmetsu da.
In an instant, we were erased . . .

Kanzen'ni hakaisa re te shimat ta.
Everything gone . . . total devastation.

Communal Witness

Jigoku da. Hateshinai jigoku da.
In endless hell.

Kawa ga chi ni somat te iru.
Rivers of blood.

Niku to hone no dampen ga, chijō wo ōt te iru.
Flesh and bones cover the ground.

Dare ga kono jigoku wo motarashi ta no da?
Who created this?

Kono yo no owari da.
The end of the world.

Watashi wa, nani wo shi ta no da?
What have I done?

Watashi tachi wa, nani wo shi ta no da?
What have we done?

Part II: Lament

INTROIT:

Anata wa Nagasaki no hito.
You lived in Nagasaki.

Itoshii Nagasaki no hito.
Your heart was in Nagasaki.

Chant Refrain:

Hikari kara hai e.
Light into ashes.

Kunō no ue no kunō.
Suffering upon suffering.

Chant Cycle I:

Nam man no hito tachi, nanjūman no hito tachi.
Thousands upon thousands.

Kunō no ue no kunō.
Suffering upon suffering.

Watashi no namida wa, watashi no uchi naru bōryoku no tame ni.
I weep for the violence within me (us).

Uchi naru bōryoku no tame ni.
For the violence within.

Chant Cycle II:

Kono namida wa, inochi wo otoshi ta hitotachi no tame ni.
I weep for those who are no more.

Kono namida wa, aisuru hito wo ushinat ta, anata no tame ni.
I weep for the loss of your loved ones.

Kono namida wa, ikinokot ta hito tachi no tame ni.
I weep for the survivors.

Watashi no namida wa, jigoku wo tsukut ta hito tachi no tame ni.
I weep for those who created this hell.

Chant Cycle III:

Kono yo no tsumi wo nozoku kami no hitsuji yo,
Agnus Dei qui tollis peccata mundi, Lamb of God who takes away the sins
 of the world.

Warera wo awaremi tamae.
Miserere nobis. Have mercy on us.

Kesshi te, hakai wo kurikaesa nai yōni.
Never again; may it be so.

Part III: Ashes into Light

INTROIT:

Koko wa Nagasaki.
We are in Nagasaki.

Itoshii machi, Nagasaki.
Our hearts are in Nagasaki.

Hikari kara hai e,
Light into ashes,

Hai kara hikari e.
Ashes into light.

Ichinichi ichinichi,
Now and every day,

Heiwa koso, inochi.
Living peace.

Motet:

Hikari kara hai e,
Light into ashes,

Hai kara hikari e.
Ashes into light:

Heiwa no kiseki wo motarasō.
Bring forth miracles of peace.

Ichinichi ichinichi,
Now and every day,

Heiwa no tame ni.
Wage peace.

Ichinichi ichinichi,
Now and every day,

Heiwa koso, inochi.
Living peace.

Garbage First

Below is the testimony I presented to the US Department of Energy at a hearing in Livermore, California, on December 8, 1993.

"Humans who think" or "Humans who work" have been terms we have proudly used to distinguish ourselves from other species. We should not ignore, however, our distinction as "humans who create garbage."

Garbage is, by definition, something we don't want. So there is a tendency in our psyche to deny the problems of garbage. But the survival of humanity and all other species may depend on how we deal with what we least want to acknowledge.

So far, humans have been incapable of adequately disposing of or storing nuclear waste that results from weapons and energy production. Plutonium, an element created by burning uranium in nuclear reactors, provides a dramatic example. One millionth of an ounce of this element is lethal to a human being, and its half-life is twenty-four thousand years. This means that a significant amount of the plutonium now in existence will last a hundred thousand years. Who can even dream of managing it for such an enormous span of time?

Management of nuclear waste was given a low research priority during the Cold War period. For the sake of "national security," the superpowers were so busy building nuclear weapons that their effort to protect the environment from radioactive pollution could not catch up. Reports from the vicinities of plutonium reprocessing plants for military production provide alarming information: At one time, eighty cows out of two hundred born near the Hanford Site, Washington, had birth defects. Radioactive water that had entered the Irish Sea from the plant in Sellafield, England, reached all the way to

Norway. Lake Karachay in Russia became so radioactive from a nearby plant that even today a person who stood at its shore for an hour would die within weeks.

It is striking that a conflict between two political systems that lasted for a mere half century has created waste that will be a threat to the global environment for one thousand centuries. We have reached a point in our development as creators of garbage when the duration of waste is not only longer than a human life, but longer than the life of a society or nation, longer than an imaginable future history.

Facing this fact forces us to give the management of garbage a much higher priority than we do now. It is crucial to construct our social and individual conduct on the understanding that production of unmanageable garbage is unethical. We must stop producing nuclear waste, both from weapons and energy production.

In November 1993, the US Department of Energy (DOE) proposed a policy to bring high-level radioactive waste from foreign nations into US ports. Both highly enriched uranium and its spent fuel, which contains plutonium, can be used to produce nuclear weapons. To avoid nuclear proliferation, the US government has promised to recover spent fuel from highly enriched uranium of US origin.

The United States should not be a nuclear waste dump site for the world. The United States doesn't even have adequate storage sites for its own domestic nuclear waste.

The DOE proposal illustrates a basic contradiction in the nuclear policy not only of the United States but of all countries that support the nuclear industry. On the one hand, we don't want nuclear waste to be in the hands of people we can't trust. On the other hand, many of us don't want to deal with the waste.

I believe that the US policy of exporting nuclear-weapons-grade material and its promise to accept the spent fuel is wrong. I propose that the United States establish a policy of refusing to export uranium. Of course, the United States should not be the sole nation to ban uranium export. There needs to be an international agreement to end the mining and trading of uranium.

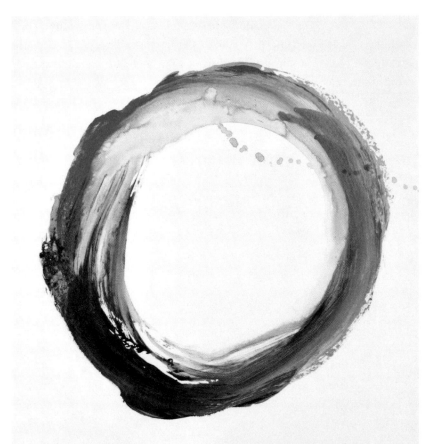

Can we recycle as Nature does?

We humans must turn our thinking around. Instead of denying the problems of garbage, we need to think of garbage first. If we can't manage the garbage, we shouldn't produce these kinds of energy or weapons. The energy and defense policies of each nation and of the international economy should give high priority to the question of how to deal with garbage. To achieve this turnaround, each one of us needs to broaden our imagination and make our moral commitment stronger than ever.

Dear Los Alamos Lab Workers

The Los Alamos National Laboratory in Los Alamos, New Mexico, is where the atom bombs dropped on Hiroshima and Nagasaki were developed and produced. It has been one of the major US research and production facilities for nuclear weapons along with Lawrence Livermore National Laboratory in Livermore, California. For a rally on the Los Alamos Lab campus, organized by Campaign Nonviolence and other peace organizations on August 6, 2015, I and some residents and friends of the Upaya Zen Center, Santa Fe, created posters and a banner. Measuring forty by eighty inches and reading "1 H bomb = 100 days of Auschwitz," the banner led us in a march through the town.

Following addresses by Father John Dear, Reverend James Lawson, and Joan Halifax Roshi, I spoke:

Dear Los Alamos Lab workers, I know you have well-paid jobs with high status. You work hard and you and your family are comfortably settled in your area.

But once the devices you are developing, testing, and producing are dropped on cities, hundreds of thousands of people are massacred within a matter of minutes. That is not good for billions of people in the world and the environment and it is not good for yourself.

> Wake up to the true nature of your work.
> Wake up to the lives of humans, animals, and the vast
> environment.

You have the power to change your own life.
You have the power to talk to your colleagues.

You have the power to help convert your lab to perform only non-weapons work, that can help stop work on nuclear weapons in New Mexico, in the United States, and the rest of the world.

Because you have the power, you have the responsibility to convert your lab.
Our friends at the Los Alamos Lab,
Please, please, please wake up to your conscience.
Wake up to your decency as a human being.

This is again my address to every worker in all nuclear bomb facilities in the world, as well as all other weapons manufacturers and traders. Readers, I hope this will also be your thought and message!

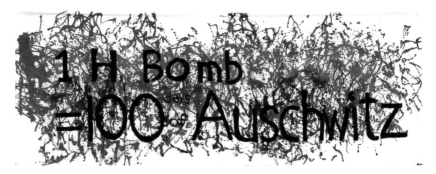

1 H bomb = 100 days of Auschwitz

Life

Your life,
my life.
Life nurtures.

Your life,
my life.
Life is sustained.

Your life,
my life.
Life is connected.

Your life,
my life.
Life is sacred.

May we affirm life.
May we nurture life.
May we treasure life.

PART THREE

Principles of Engagement

Four Commonplace Truths

The Four Noble Truths, taught by Shakyamuni Buddha soon after his enlightenment, have functioned in Buddhism as the most essential understanding of life and as suggestions for ways to achieve liberation. They are:

1. Suffering is pervasive in life.

2. The cause of suffering is craving/self-centered desire.

3. Nirvana (experience of nonduality) is a realm free from suffering.

4. The means for attaining nirvana is the practice of the Eightfold Noble Path.

The Eightfold Noble Path is wholesome understanding, wholesome thoughts, wholesome speech, wholesome action, wholesome livelihood, wholesome effort, wholesome mindfulness, and wholesome concentration.

The aim of these principles is to rescue individuals from anguish so that they might achieve personal liberation.

Social services, such as care of the sick and aged, feeding the hungry, and education, have all been important elements in Buddhist practice. In this regard, Buddhism has been engaged in social issues throughout history. But when an increasing number of people in the Western world started practicing Buddhism in the last half of the twentieth century, the concept of Engaged Buddhism emerged. It is an attempt to apply Buddhist teaching to the realm of social transformation, including peace and environmental work.

Then, there arises a question: Are the Four Noble Truths sufficient to be the guiding principles for social transformation? Or do we need other principles for social engagement?

Some of you may say that the Four Noble Truths are enough and all we need to do is to reinterpret them at a time when the survival of humanity and the earth is at stake. Others may say that we need new principles of action to supplement the Four Noble Truths.

I personally felt a need to summarize the commonsensical and basic belief I have been following unconsciously while participating in peace and environmental work. Thus the concept of the four commonplace truths has emerged. These truths are:

1. No situation is impossible to change.

2. A communal vision, outstanding strategy, and sustained effort can bring forth positive changes.

3. Everyone can help make a difference.

4. No one is free of responsibility.

You may notice the Buddhist teaching of impermanence in the first principle. As I have suggested, these principles have been inspired by the Buddha's teaching, more than two and a half millennia old.

But action for peace, the environment, and social justice should not be confined by religion or ideology. Likewise, these principles ought to be universal. They must be tested in all situations by all groups of people before they can definitely be called "truths." Until then, these four principles will merely be candidates for truths.

Ten Laws of Breakthrough

When a change that seemed impossible becomes possible, we call it a breakthrough. Breakthrough may be understood as a sudden and overwhelming unfolding of freedom from long-held limitations.

A change can happen on personal levels—physical, emotional, mental, and behavioral patterns such as addiction, obsession, and abuse—as well as on relational levels. It can also happen on social levels. In this case the limitations to be overcome can be lack of scientific knowledge or technological capacity, as well as the existence of prejudice and injustice.

Thus, breakthrough can be a key concept for social transformation. But, just like *campaign, operation,* and *strategy,* the English word *breakthrough* is closely related to military action and has violent connotations. It suggests crushing the frontline of the other side and destroying the enemy.

For the East Asian counterpart of the English word *breakthrough,* I suggest the ideograph *zhuan* in Chinese (pronounced *ten* in Japanese, *chon* in Korean, and *chuyen* in Vietnamese). It means "to turn," "to rotate," "to roll," "to shift," or "to change." This word serves as a reminder that our real objective is perhaps to change the situation, rather than to remove or crush the block. We may want to bring forth a drastic change nonviolently, not only for others but for our own body, mind, and life.

I have had a number of opportunities to talk with people in various fields whom I meet in conferences and who also come to my brush seminars, where I teach East Asian learning and creative processes using calligraphy and Zen painting as the main tool. "Breakthrough with the brush" has been one of the themes of my classes. In particular, Julian Gresser, an international environmental lawyer, helped me clarify the "ten laws of breakthrough":

1. Breakthrough may or may not occur. The result is unpredictable, and how it happens is mysterious. All we can do is to work toward breakthrough.

2. Some breakthroughs are life-affirming, and others destructive.

3. The chance for breakthrough increases when the objective and the process are clearly stated.

4. The chance for breakthrough increases when the blocks are clearly identified.

5. The smaller the objective is, the larger is the chance for breakthrough.

6. An effective, intense, and continuous effort builds a foundation for breakthrough.

7. The more forces combine, the larger is the chance for breakthrough.

8. The greater the objective is, the easier it is to bring together force for breakthrough.

9. The chance for breakthrough increases when more attention is directed to the process than to the goal.

10. Nonattachment is a crucial element for breakthrough.

Most of these "laws" are very straightforward and logical. Laws 5 and 8 may look contradictory, but they are not. It is beneficial to have a large objective in order to collect large forces together, but it is helpful to break up the problem into smaller segments in order to accomplish the objective. Laws 6 and 10 may also look contradictory. Attachment is clinging to success, which leads us to disappointment, upset, and depression when we fail. Detachment is giving up and being indifferent. On the other hand, nonattachment is freedom from being confined to the objective and helps us to be more engaged.

I believe law 2 is the most important of all. Human society, as well as the environment, is suffering so much due to recent scientific, technological, and commercial breakthroughs. We need to examine rigorously whether what we want to achieve is going to be life-affirming to all beings in the long run.

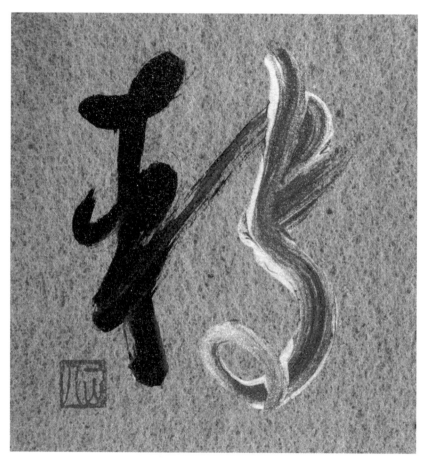

Breakthrough

Breakthrough Spirituality

The symposium "Art and the Sacred" was held at the Cathedral of Saint John the Divine, New York City, in March 1997. The construction of this Gothic-style building began over a hundred years ago. I noticed that its south tower had grown a little since I had seen it ten years before, though the construction of the north tower had not yet started.

The invisible portion of the mammoth structure gave me a sense of assurance that humans will continue to build civilization after my own death and the deaths of all those who are alive now. But soon I remembered that the chance for humans to survive for another century is decreasing rapidly. So I said at the symposium, "The thought that humanity may not see the completion of this building is daunting."

Our best chance for a major breakthrough to avert the imminent social and ecological catastrophes before us is through the sustained effort of those engaged in spiritual paths. Meditation, contemplation, and prayer can help us to become simple, humble, and truthful. Insights that emerge from such spiritual disciplines strengthen our ability to care for others—in this and future generations.

The terms *religion, spirituality*, and *the sacred* have various interpretations. Words like *love, justice*, and *art* can mean different things according to speakers and listeners. It is crucial, then, to clarify our language to reduce the chances of misunderstanding. The meanings of *religion, spirituality*, and *the sacred* often overlap.

In my view, spirituality is largely a process for experiencing the sacred. The sacred is someone or something we revere or devote ourselves to—including, but not limited to, God, the gods, the Buddha, buddhas, ultimate reality, and the source of life. The sacred also includes the environment of

the divine, and the settings, teachings, rituals, or vocations that enhance our experience of unconditional dedication.

Religion is the institutional structure that results from an encounter with the sacred. It is a complex system of languages, symbols, doctrines, practices, and patterns of community life. Although spirituality is the source of religion, and is often found in religion, it is possible to be spiritual without being religious. That is, we can participate in those practices through which we encounter the sacred without necessarily adopting the institutional setting which develops around it.

Religion, science, art, and politics are all tools that are intended to enhance the happiness of individuals and society. On the other hand, as history demonstrates, they have often been used to blind, exploit, divide, traumatize, and destroy people. We need to be aware of the traps of these great disciplines as well as their powers and benefits.

Spiritual practice enables us to be deeply in touch with ourselves and one another. The more we realize the boundless interconnections among all beings, the more of our self-centeredness is replaced by love, understanding, and compassion.

Whether it is yoga, sacred dance, meditation, or participation in a mass, church choir, or tea ceremony, spiritual practice largely follows a defined format. In fact, at the heart of spirituality is a mindful repetition in which our energy goes deeper and deeper. Being immersed in such a repetitive practice is often a relaxing and satisfying experience. Being so engaged in spiritual activity we become less driven by desire, particularly by the unwholesome desire to acquire more and more material objects and power. In place of desire we become simple and humble and, in this way, more fully spiritual.

When Jesus was healing the blind or when the Buddha was speaking to fellow seekers after his enlightenment, each manifested spiritually but not yet religiously. What they did in their lives was to achieve initial breakthroughs, new unfoldings of freedom from the limitations that had been in existence since the beginning of humankind. Jesus's initial breakthrough, expressed by his words "Love your enemy," has been re-experienced by billions who have followed his path. Similarly, the Buddha's words, "I am enlightened together with all beings," opened a path to repeat breakthroughs over centuries.

Gandhi's challenge—to respond without military arms to the world's largest empire—was likewise an initial breakthrough for nonviolent social change. His deeply spiritual principles have subsequently been adopted by others, as in the civil rights movement in the United States and in the challenge to apartheid in South Africa.

Initial breakthroughs transform the impossible into the possible. In most cases we do not need to achieve an initial breakthrough ourselves, but we must learn to relive such breakthroughs in our own context. When successful, the new context may unintentionally evoke inherently unique breakthroughs.

A spiritual path is often described as the "way"—the *dao* (*tao*) in Chinese and *dō* in Japanese. In East Asia, art is part of the dao, not merely creating something beautiful, but participating in an imaginative expression of feeling, understanding, and vision. In this sense science, medicine, philosophy, and politics can be art.

In the dao, art and the sacred are not separate. But if we take these two disciplines apart, it is possible to say that the sacred is often the foundation of art and art the vehicle of the sacred. Among the numerous prophets and mendicants who have had highly spiritual or mystical experiences, there have been few who could express themselves so convincingly as Jesus or the Buddha. But these pioneers of the great religions had a genuine presence and power of language that have inspired people of all generations. As masters of communication, they were artists.

Spiritual practice can help art to be truly imaginative, bold, and visionary. Art can empower the wisdom and love of those engaged in spiritual paths. Together, art and the sacred can realize a miraculous effect. By transforming individual consciousness, humanity is itself transformed in the path of protecting the life of all beings. What can be more sacred than this?

Sing a Song of Peace

Sing a song of peace
　That may change your heart forever.

Sing a song of peace
　That may change our hearts forever.

Sing a song of peace
　That may change the world forever.

What Can an Artist Do?

You may think you know what artists are, how significant they are, and how to work with them. But your ideas and those of others may be far apart from each other. So we need to examine some of the basic questions about artists.

I would like to present my exploration in the form of a bare list. This list was originally given to Elias Amidon, codirector of the Boulder Institute for Nature and the Human Spirit, based in Boulder, Colorado. He had invited me to the inaugural meeting for the East Asian Peace Initiative to be held in Thailand in January 2002. I was unable to attend, but wanted to assist him in developing thinking on finding and working with artists. Here you are:

WHAT IS AN ARTIST?

1. An artist is someone who makes full use of imagination—
 who goes beyond the boundaries of conventional seeing and
 thinking.

2. Sometimes musicians use the term "artists and musicians,"
 in which case "artists" are limited to visual artists (as in art
 department and music department). But musicians are also
 artists. Poets and other types of writers, speakers, thinkers,
 journalists, designers, architects, performers, photographers,
 and filmmakers are all artists.

3. We should not limit an artist to someone who makes a living
 with art. Everyone has elements of artistry. Everyone can be,
 and in fact, is an artist.

WHAT DOES AN ARTIST DO?

1. Dreams and fantasizes, envisioning what seems to be impossible as possible. In this regard many scientists, social reformers, and entrepreneurs are artists.

2. Creates concepts, perspectives, paradigms, terms, languages, mottoes, images, symbols, sounds, feelings, and forms.

3. Communicates by drawing attention, asking questions, sending messages, and persuading.

4. Helps bring people together by involving them in common creative activities, discussions, and sharing of thoughts and visions.

WHAT ARE AN ARTWORK'S QUALITIES?

1. Beautiful, pleasing, enjoyable

2. Imaginative, wild, unique, thought-provoking

3. Surprising, unexpected, free

4. Exciting, moving

5. Hopeful, uplifting, inspirational

6. Spiritual, religious

7. Genuine, authentic, true

8. Traditional, disciplined

9. Realistic, representational

10. Cultural

11. Global

12. Progressive, holistic, enlightened

13. Profound, subtle

14. Life-affirming

15. Consciousness shaping, priority shifting

16. Prophetic, futuristic

17. Convincing, effective

18. Practical, useful, helpful

HOW DOES AN ARTIST WORK?

1. Identifies issues and objectives

2. Deconstructs preconceptions

3. Starts from not-knowing

4. Is as unconventional as possible

5. Lays out a process for maximizing creativity

6. Identifies the most effective use of concepts, terms, languages, images, symbols, sounds, forms, and feelings

7. Creates effective expressions

HOW DO YOU WORK WITH ARTISTS?

1. Identify the existing and potential audience: collaborators, public, media, supporters, and funding individuals and organizations.

2. Identify the objectives.

3. Identify the types of artwork needed to communicate with the audience.

4. Identify the most suitable artists conceivable to work with for creating such artwork.

5. Identify the most suitable conceivable process to work with them.

6. Create the most suitable conceivable expressions with them.

7. Realize that the more you want from artists or from your artist within, the more effective you may be.

HOW DO YOU FIND ARTISTS?

1. You are also an artist. Much of the artwork can be done by you yourself. But if someone else can do the work better, let that person do it.

2. The regional and cultural background of the artist(s) is critical if your audience is regional and cultural.

3. If you are clear about what kind of work you want from the artists, you or your collaborators may be able to identify the names of potential artists to work with.

Consider Integrity in Choosing Your Career

Please consider *integrity* as an essential factor in choosing your career. A conventional definition of integrity is being honest and reliable. But this is not enough, as so-called honest and reliable people could participate in harming other people and the environment. We need a new understanding of integrity with a global perspective. The life of the planet is in our hands. Lives of people all over the world are in our hands. We need to consciously choose a direction that nurtures the well-being of all people and the environment.

You might consider developing your own definition of integrity. For the time being, however, let's define integrity as "the wholeness of a person as a life-affirming part of the human society in an ultra-long span of time." "Wholeness" suggests inclusion of all parts of yourself—scientific knowledge, artistic creativity, love, spirituality, ethics, and service. Your job should enhance the health and well-being of yourself, your family, your community, your country, and the global community. You would lack wholeness if you were to serve only your family or your country. If your job were to harm your health, there would be something severely wrong about it. Your job might be good in respect to the short term, such as decades, but might not be good in respect to centuries. If so, please reconsider.

You might say that this is too idealistic and that reality is not so simple. The majority of jobs in science in the United States seem to be directly or remotely related to defense. You might feel you should justify your education and get a job that suits your training. You might feel strongly drawn to the high salaries offered by the tobacco and weapons industries. This is when you need to reconsider.

Your life can be that of awakening. Awakening is realizing the infinite value of each moment of your own life as well as the life of other beings, then continuing to act acordingly.

What if you had a job that paid well and gave you high prestige, but the nature of the work was bound to bring about sickness, unhappiness, or disaster in people's lives? You might have to hide or deny what you were doing. Your self-esteem might not be high, and you might feel your whole life was wasted. A typical example of such "destructive work" might be found in the tobacco or weapons industry.

In choosing your career, you have various factors to consider: salary, benefits, vacations, level of challenge, promotion, prestige, work site, community. It is important, however, to examine whether the job you consider is life-affirming for yourself and others, and whether you genuinely feel joyous and proud.

For example, if you work in the tobacco industry, the harder you work and the more successful you are, the more people will get sick and die. Without killing anyone in person, you might make a considerable contribution to increasing the number of potential lung cancer patients and their deaths. Is this good for the well-being of our society? Is it good for your psyche?

Or, let's say your job is related to increasing the explosive power of hydrogen bombs—to kill millions of people instead of hundreds of thousands in one blast. Do you think you will receive full respect from your friends by doing such work? Will your children and their children be proud of your life's work?

There are endless ways to justify jobs in the tobacco or weapons industry: helping the economy, increasing employment and exports, free enterprise, defense, national security, or protecting democracy. Some people may truly believe in such missions. But if you had a choice, would you choose to take a job that is harmful by nature?

Whether or not you smoke, you do not want your children to be exposed to smoking. You might feel all right, however, about designing an attractive poster or billboard for a tobacco company. This behavior is not consistent.

You yourself are committed not to murder. You might feel it harmless, however, to serve food or be a guard at a weapons factory, or a scientist at a defense-related research center. This is not consistent. You may not push a

button to launch a missile, but you are part of an institution that develops and produces the means of massacre. Your hands are not clean but bloody. Whether or not you realize it, this will numb your conscience and damage your personality.

Is it true that you have no other choice? You do have a choice. In a free society there is always a choice. Your life can be led with full integrity. The life you live is the life you determine to live.

Don't Be a Scientist of Death

Young friend,
choose a life that affirms life—
yours and others'.
 Don't be a merchant of death.

Young friend,
choose a life that nurtures life—
yours and others'.
 Don't be a scientist of death.

Young friend,
choose a life that sustains life—
yours and others'.
 Don't destroy the earth.

Creative Laziness

A common notion of laziness is that it is counterproductive. I would say, however, there are cases in which the lazier we are, the more productive we become.

At times it's good to slow down and be lazy, especially when there is so much strain on our body and mind to the point that our health is threatened. In fact, it is imperative to slow down when our body sends us critical stress signals.

In Japan there is a saying: "Living long is part of the art." The healthier we are and the longer we live, the more chance we have to create and serve others.

Is it not uncommon for us to be so focused on goals that we cannot be free from anxiety until we reach the point of completion? The steps toward the goal remain partial as long as the goal remains unattained, so a drive toward fulfillment of the goal dominates our life.

In *Brush Mind*, an earlier book of mine, I suggested: "It's a tough job to be lazy, but somebody has to do it. Industrious people build industry. Lazy people build civilization."

I take this as a reminder to myself that I, along with the rest of the world, need to slow down. If we enjoy working so much that we forget to stop, then our health may be harmed. Those who are lazy on a regular basis don't need such a reminder, but workaholics should try it for a change.

East Asian calligraphy is the main art that I practice and teach. The ideographic calligraphy has been a common art form for the Chinese, Vietnamese, Koreans, and Japanese. Some Chinese calligraphers are particularly known for their meditative brushstrokes similar to the slow movements of

the traditional Chinese martial art, *taiji* (t'ai chi). You might find it useful to follow this aspect of art practice.

When you try to move the brush slowly for the first time, you might find it difficult to keep control of the brush movement. You might also experience a conflict within. Part of you may want to slow down. On the other hand, you may feel the urge to go back to your usual mode of doing things quickly in order to finish drawing and get it out of the way.

With time and practice, however, you would probably get accustomed to the relaxed pace, becoming aware of each subtle variable of the brush movement and its relationship to your body and mind. You might even come to love it and enjoy drawing each stroke. Each line, like the moment in which it was drawn, carries a timelessness and completeness of its own.

No line you draw has to be perfect. On the contrary, you may keep drawing clumsy lines. Of course you improve your lines little by little, but it's rather unrealistic to expect to become a master right away. Yet, even if the line might be imperfect or not look so great, the act of drawing a line is complete. Regardless of the appearance of the product, we become free of struggling for accomplishment or creating something perfect.

If life is goal-oriented, as soon as one goal is achieved other goals appear; we become anxious for achieving goals most of the time. If, however, we enjoy each step of the way, each step in turn becomes the goal. We can enhance relaxation and the density of our life enormously.

Meditation is an excellent way to help us to enjoy being slow and doing less. The practice of a meditative art, such as yoga, the tea ceremony, and martial arts, can bring forth similar effects.

Laziness does not mean doing nothing but doing less. It can also mean being effective. (As I like to say, "I am too lazy to be ineffective.")

When you have a big project or when there is a crisis, you may want to take action immediately. But it may be wise to choose to do nothing for a while and contemplate the best way to deal with the situation. In this case, practicing no-action can be the best action. No-action contains boundless potential for action.

action

no action

The study of aikido in my youth with its founder, Morihei Ueshiba, has been my foundation for meditation in action. As I mentioned before, he would sit square on the wooden floor of the small dojo and let some of us push him as hard as we could. Instead of being pushed down he would relax, smile, and absorb all the incoming forces.

In this act, he showed us the power of physical and mental relaxation. In recent days, over fifty years after my lessons, I have come to suspect that he was demonstrating the most profound secret of martial art: the power of being immovable.

Some of the movements in aikido are spectacular—throwing the opponent in the air with no touching, or throwing down multiple opponents in one sweeping motion. We students were exposed to such miraculous maneuvers day by day. I had easily overlooked the significance of the master just sitting still on the floor.

Ueshiba taught me the value of both motion and stillness. Motion is all the actions we take in our lives. Stillness means total groundedness. It is not only the lack of motion but the foundation of it. Motion and stillness—busyness and laziness—are equally important. And because most of us are busy all the time and ignore laziness, it is beneficial sometimes to focus on cultivating laziness.

Once, someone invited me to participate in a peace conference. After meeting her some time before the conference and making the necessary arrangements, I asked her, "Are you having fun?" She said, "No. I have so many things to do. I have no time to enjoy myself." I just looked at her with no remark.

Later she thought about our conversation and realized that it was not good that she was not enjoying the process of preparing one of the largest undertakings in her life. So, she and her husband took one week off and spent a restful vacation on a small island in Greece. I was impressed at the serene and graceful manner with which she conducted the conference.

When my colleagues and I were fully engaged in the work for Plutonium Free Future, I would say, "The most important thing about our work is how well each one of us is, and how much we enjoy our work. If we get sick, we cannot do the work. If we don't enjoy the work, we should do something else."

This may sound self-centered, but in fact it is a way of becoming selfless, centered around laziness.

The power of doing nothing is amazing. You might think reading, watching television, or following a meditation schedule is doing nothing. But really doing nothing may be beyond any of these.

Suppose you are in a cottage in the mountains and do nothing except for drinking water, eating, doing exercises, and taking notes. You might be afraid of being bored. Yes, you would be bored all right. But remember: Boredom is the greatest companion of laziness. All creative thoughts and actions derive from a state of unstained boredom.

Some of you may be too lazy to find and go to a cottage in the mountains. If this is the case, try practicing ultimate laziness at an airport or in a train. It is guaranteed to succeed, providing you don't miss your plane or leave your suitcase behind at the train station.

Why Dogen?

Dogen, a thirteenth-century Zen master, said, "Miracles are practiced three thousand times in the morning and eight hundred times in the evening." In his time, and in fact through most of the history of Buddhist monastic practice, the midday meal was the main meal and often the last one of the day. People were sleepy in the afternoon, when they had a miraculous bit of free time.

An attraction of Dogen for many of us in a time of advanced science and technology is that he didn't regard miracles as magical or supernormal phenomena that might be brought forth by rituals or prayers. According to him, miracles are such daily activities as fetching water and carrying firewood. Every encounter we have is a miracle. Every breath we take is a miracle. But, as we often focus on imperfection, lack, and failure, we become cranky and unhappy. So Dogen's words can be a good reminder of the miracles of each moment.

People say, "How many years did it take you to put the Dogen book together?" I sometimes say, "It took us seven hundred and fifty years." This is true if we take into account that Buddhism practically didn't exist in the West until recently. In the sixteenth century a Portuguese missionary reported a strange kind of demonic worship in Japan. When this was the typical European perception of Buddhism, there was no need for Dogen in the West.

Zen was formally introduced to the United States in 1893, when Soyen Shaku gave a lecture at the Parliament of World's Religions in Chicago. D. T. Suzuki, one of his students, wrote a lot about Zen but seldom mentioned Dogen.

In my twenties, when I was a beginning artist looking for a spiritual guide, I read Dogen's poems and essays, which blew my mind. Here is the passage that inspired me most:

Birth (life) is just like riding in a boat. You raise the sails and row with the pole. Although you row, the boat gives you a ride and without the boat you couldn't ride. But you ride in the boat and your riding makes the boat what it is. Investigate a moment such as this. At just such a moment there is nothing but the world of the boat. The sky, the water, and the shore are all the boat's world.

I had been studying European literature and philosophy, the writings of the existentialists in particular. Camus points to the impermanence of life, in saying that we are all on death row. In my view, the existentialists expressed helplessness, despair, and boredom because they tried and, by and large, failed to find a "way out" from a helpless situation after they declared that "God is dead." When I saw Dogen's positivity, it was as if he were presenting the next step to an existentialist understanding.

I didn't have a firm grip on what Dogen was talking about, and perhaps because of that, I was drawn to him. In 1960 I held my first art show in Nagoya, Japan; it took place in a rented gallery, and was a six-day show, as was common in Japan. There was an old man, Soichi Nakamura, who came to my show every day. We became friends. I realized that he was an accomplished scholar and Zen teacher.

I said to Nakamura Roshi, "Dogen is amazing but it seems few people understand his writings. It would be a great help to many people if you would translate Dogen into modern Japanese."

He said, "I would, if you do that with me."

So I said, "I would be happy to work with you." I thought I would work with him for a few years, get that project done, and then do something more interesting.

Translating Dogen's paradoxical words from medieval Japanese and Chinese into modern Japanese was extremely painstaking. Sometimes we worked for a whole day on just one line. I started studying Sanskrit—which is essential to understanding Mahayana Buddhism—with a tutor and Chinese as well as Buddhist philosophy.

At one point I was invited to have a show in Washington, DC. It was January 1964. I was thirty years old when I landed in Honolulu in my first

visit to the United States. There I met Robert Aitken, who was not a *roshi* yet. He gave me a list of Zen places to visit on the mainland and suggested that I meet Reverend Shunryu Suzuki in San Francisco.

I visited his temple, Soko-ji, and had a friendly conversation with Suzuki Roshi for about one hour. He must have been wondering what I was. Finally he said, "Are you a salesman of Buddhist goods?"

I said, "No, I am not. I am a student of Zen master Dogen."

Then I said to Suzuki Roshi, "I understand you teach zazen here. What kind of text do you use?"

He said, "*The Blue Cliff Record.*"

I said, "Why not Dogen?"

"Dogen is too difficult for American students."

"Don't you think you should present your best when you teach foreign students? It doesn't matter if they don't understand it. Don't you think Dogen is your best?"

After a few moments of silence, he said, "I am scheduled to give a talk to my students on Sunday. Would you please talk about Dogen for me?"

I had never given a public talk in English. I borrowed a copy of his Dogen book and wrote a lecture. My topic was "time" based on "Time Being," a fascicle of Dogen's major work, *Shobo Genzo*, or *The Treasury of the True Dharma Eye*.

After showing my artwork in North America for one year, I went back to Honolulu and translated "Genjo Koan," another fascicle of *Shobo Genzo*, with Bob Aitken.

Returning to Japan, I suddenly found the work of translating Dogen into modern Japanese much easier. Translating it into English had changed the dynamics. When you translate something into another language, you have to deconstruct the structure of the original sentence and try to find the best possible syntax to make it sensible in that language. Some kind of breakdown process had taken place, which opened up my mind.

So I said to Nakamura Roshi, "It might be a good idea if you would let me do the translation by myself and comment on my draft afterward." I dictated my modern Japanese translation into a tape recorder and asked a team of volunteers to transcribe it. We completed the entire ninety-five fascicles of

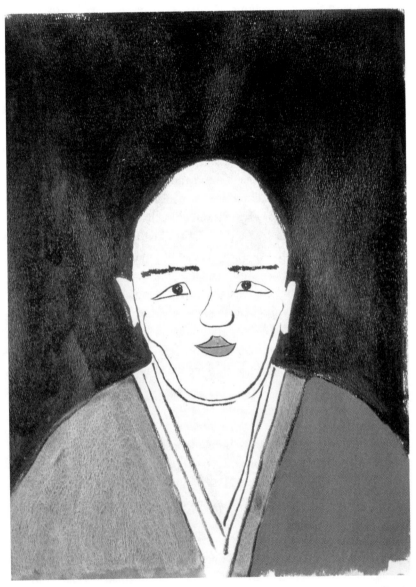

Dogen

Shobo Genzo, which were published in four volumes in original and modern Japanese with the extra volume of a *Shobo Genzo* glossary in 1972. It had taken us twelve years.

At one point I thought of translating more of Dogen's writings into English. As Suzuki Roshi had by then passed away, I wrote to Richard Baker Roshi, his successor as abbot of the San Francisco Zen Center. When I met him in Kyoto in 1975, I expressed my wish to collaborate with those who were practicing Zen in translating Dogen.

Baker Roshi asked me directly: "Are you a Buddhist?"

I said, "Well, I am a Buddhist scholar."

"Why don't you come to Zen Center and work with us?" he said.

In 1977 I moved to San Francisco and worked at the Zen Center for seven years. *Moon in a Dewdrop* was the result of a collaboration with its members from that period. The Zen Center and I worked together after I became a freelance artist and writer. We have created two more Dogen books: *Enlightenment Unfolds* and *Beyond Thinking*.

Dogen was extremely serious and formal, a high spiritual leader and excellent community organizer. I'm the opposite. I like to be informal. I like to think beyond the boundary of any tradition and identify myself as a dropout. In no way would Dogen consider me a good student. But I am attracted to his worldview and teaching, and wish to support, in a modest way, those who are following his path.

Dogen said:

By the continuous practice of all buddhas and ancestors, your practice is actualized and your great road opens up. By your continuous practice, the continuous practice of all buddhas is actualized and the great road of all buddhas opens up. Your continuous practice creates the circle of the way.

We receive a great teaching, and we actualize it. We receive a great heritage, whether it is a common human heritage or a spiritual heritage, and it is we who make it vital. Teachers are students and students are teachers.

A few years after bringing the Zen teaching from China, Dogen tried to build a small monks' hall. He said in his fundraising letter, "We will thoroughly engage in each activity in order to cultivate fertile conditions to transform the ten directions." This is an outrageous statement. By taking care of every small detail of life—sitting, walking, cooking, and cleaning—he wanted to change the world.

One of his tasks was to establish a practicing community by encouraging its members to be sensitive to other people's feelings, to be fair and open, and not to interfere with others' responsibilities. What Dogen was doing was small, but the effect of his thinking and practice has proven to be enormous, and his influence is still growing. It is ironic and inspiring that being thoroughly engaged in each activity, while working with others harmoniously, may be the most immediate way to bring forth large-scale transformation.

This is an exciting time for those of us who love Dogen. His work is widely studied not only in monasteries and dharma centers but in prestigious universities. A number of other scholars and dharma practitioners are engaged in translating Dogen's writings. Over fifty books have been published on Dogen in English. And still I am translating more of his writings. Why?

Because I just love Dogen. He helps me live harmoniously with myself in the moment with others. He is wise, imaginative, and timeless. Furthermore, he has ultimate optimism. When problems around us are enormous and we tend to be helpless and cynical, we need to be encouraged with positivity—the trust that each action we take has the power to transform ourselves and others.

One Life, One World

The human mind has infinite capacity. Our actions can range, on the one hand, from being inconsiderate to others, producing weapons, engaging in criminal activities, or waging war to, on the other hand, being considerate, seeing others as no higher or lower than ourselves, engaging in ethical conduct, and working for peace. We can prioritize division, fight for a company, party, nation, or harden our views on border disputes. We can focus equally on going beyond borders, working on climate and other environmental issues, and world peace. Our attention to borders could be through working with organizations such as Doctors Without Borders or by helping refugees.

Diversity is what characterizes us all. We can define ourselves by our gender, race, nationality, religion, sexual preference, family, organizations, possessions, profession, ideology, political inclination, locality, hobby, what we want to do in life, our physical conditions—the list goes on. It is essential to recognize and honor the diversity of us all and act accordingly. However, if we merely abide in our differences, we become narrow-minded and shortsighted.

Poetry can make us patriotic or ethnocentric, but it can also liberate us from our perception of the world as divided. On the other hand, in your creative imagination, the infinite capacity of the mind manifests as you become a bird, a frog, or an angel. You can make flowers bloom, create an oasis, or let a mountain walk. You can be far away in the distance, in the past, or in the future. You can be inclusive of time, whole of space.

Contemplation or meditation brings us to the deepest part of our consciousness where we humans are not divided—we are one mind. Larry Dossey suggests in his groundbreaking book *One Mind: How Our Individual Mind Is Part of a Greater Consciousness and Why It Matters*, "All minds are

already connected nonlocally as a unitary whole." Unfortunately, not many of us are aware of it. Yet we are one mind through the collective consciousness.

The lives of people are also intricately connected—intimately or remotely. If we were to look at ourselves from a faraway star, we would see we are certainly all-connected as one living system. After all, we all begin as just a few number of cells in our earliest stages of life. Thus, we are one life.

This experience of oneness is a part of different spiritual traditions, particularly mysticism. Certainly in Hindu and Buddhist traditions, this perspective is the essential part of teachings. This view of nonseparation may be called the nonduality that transcends all differentiations and sees all things as one.

For example, the *Heart Sutra*, the most widely recited scripture in Mahayana Buddhism, presents the teaching of freedom from all differentiations that come from our normal perception and discernment. The sutra encourages us to see all things as empty of divisions and without boundary (which is the Buddhist notion of what "emptiness" means). In my book *The Heart Sutra*, I suggest that what is commonly called nonduality actually means nonplurality and should instead be called "singularity."

I talked about my apprehension about the word "nonduality" at a Science and Nonduality Conference in California. At any rate, it is notable that a number of scientists are looking at "nonduality" as a way to experience ultimate reality. For example, Robert Wolfe asserts in his book, *Science of the Sages: Scientists Encountering Nonduality from Quantum Physics to Cosmology to Consciousness*, "Whether one looks out at the mysteries of a vast cosmos or narrows the view to the counterintuitive behavior of a subatomic particle, I would not be alone in maintaining that nonduality is the basic principle that explains the Whole."

If we climb on a deep mountain or walk in a large field, we realize that we are an extra-tiny part of the vast planet and that nature belongs to none of us. Instead, we belong to an incredible world. We are all one world.

The realization of oneness does not mean we should ignore or belittle our normal perceptions and discernment of things that are diverse. The difference between long and short, momentary and timeless, right and wrong, life and death, are crucial in our daily lives. All things have boundaries, and

if we ignore them, we may be gravely mistaken or unethical. Oneness and manyness are equally essential to our daily lives.

If we see all lives and the entire world as one, we can be open to experiencing other people—including so-called "enemies"—as not separate from ourselves. We will see people in the future as important as ourselves. We will conceive of other species and nonsentient beings as not separate from us.

Consciously or unconsciously, many of us who work for the environment and for peace are conducting our personal and social actions based on this "one life, one world" paradigm. That means the conversation on this theme needs to be expanded and elaborated.

Share the Earth

Stars in the vast sky—
their light travels hundreds and thousands of years
to reach every one of us.
Why don't we share our food?

Stars in the vast sky—
their light travels hundreds and thousands of years
to reach every one of us.
Why don't we share our happiness?

Stars in the vast sky—
their light travels hundreds and thousands of years
to reach every one of us.
Why don't we share our earth?

PART FOUR

Shaping Our Time

Sing

Every song we sing
carries our feeling of the moment.

Every song we sing
carries wisdom from the past.

Every song we sing
carries the spirit of our time.

Every song we sing
carries our dream for our children
and their children.

Bristlecone Pine

Bristlecone pine trees form sparsely spaced groves on high deserts in the western United States. Some of these trees, alive now with their bare trunks crooked, twisted, and torn, were already standing when King Ashoka renounced violent aggression in his Mauryan Empire, which was dominant in north India in the third century B.C.E. Many of the trees we see today were growing when Sunzi wrote *Art of War*—his discourse on economy, diplomatic alliance, intelligence, and strategy for the survival of a small kingdom during China's warring era in the fifth century B.C.E. Some of the trees still living were a couple of centuries old when Egyptians began to build pyramids around 2700 B.C.E.

These oldest living things on earth are found on the White Mountains, southeast of Yosemite, in California near Nevada; and near Wheeler Park in eastern Nevada. "Younger" bristlecone pines are also found in Utah, Colorado, Arizona, and New Mexico.

The fact that the bristlecone pine can live to be older than four thousand years was discovered by Edmond Schulman, dendrochronologist, in the 1950s; his study was published in 1958 soon after his death. In 1964, Donald Currey, a geographer, found the oldest-looking tree on a mountain near the Nevada-Utah border and cut it down with a chainsaw. By counting its annual growth rings he determined the age of the tree as four thousand nine hundred years old. (I often wonder why he did not wait to conduct his study until a technology to measure the age of the tree without cutting it was developed. This is one of the incidents that demonstrates scientific barbarism.)

The Patriarch Grove, spread over gentle hills of light gray sand and ragged limestone gravel, is located at eleven thousand feet near the top of the White Mountains. Corpses of bristlecone trees are scattered all over the

barren ground, creating a large spread of surreal, desolate landscape. Just like the aftermath of a sweeping storm, broken-off trunks remain here and there, mixed with living shrubby trees with trunks covered in brown bark and branches holding green needles.

Some of these trees have been lying on the ground for over seven millennia. Through their phases of standing and lying, they have witnessed human civilization since its dawn, when agricultural society began to form about ten thousand years ago. A visitor there is immersed in the awesome presence of these wise and persevering beings.

These trees have responded to their dry and harsh environment by growing slowly, keeping the wood extremely dense and the crowns compact. Grown-up trees are less than fifty feet tall. The lack of bacteria and fungi, related to the sparsity of leaf litter and ground vegetation, keeps the wood from decaying.

Davis Te Selle, a printmaker friend, sat on a hillside of the White Mountains, took out a glass plate, and started to make a detailed landscape drawing on it. I walked around near him while making quick drawings in my sketchbook. I wanted to capture the wildly eccentric deformation of the trunks and branches, whipped and shaped by countless sand and snow blasts. Branches coiled around each other like snakes. Exposed wood grains around knots flowed like streams along rocks. The radically shifting thickness of a trunk resembled a sensuous feminine body. The tip of a torn-apart root was the beak of a mysterious bird.

It was in July 1998 when my family and I visited the White Mountains with a group of unique individuals. Mark Gonnaman, a graduate student at Stanford University in Buddhist studies, had organized the trip. Davis and his fiancée, Stephanie Kaza, were the illustrator and author, respectively, of *The Attentive Heart: Conversations with Trees*. Stephanie had given us a list of things to bring. Her advice to bring gallons of water was extremely useful, as there were no water facilities in the campground where we stayed in the lower part of this national forest.

Linda and I were fascinated by the on-site briefing by Stephanie, a specialist in biology and environmental studies. Our son Ko, age twelve, asked

her many questions about birds. I showed our daughter, Karuna, sixteen, how to adjust the apparatus and shutter speed of our camera. She and I went off the trail looking for young bristlecone pines, and were delighted to find a sweet little baby plant, only a couple of inches high.

I first heard about this plant when Gary Snyder gave a reading of his life-work *Mountains and Rivers Without End* at a church in Berkeley soon after its publication in 1997.

Japhy Ryder, who was Gary's character in Kerouac's *The Dharma Bums*, said in that book, which was first published in 1958, "I will do a new long poem called 'Rivers and Mountains Without End' and just write it on and on. . . . It will be packed full of information on soil conservation, the Tennessee Valley Authority, astronomy, geology, Hsuan Tsung's travels, Chinese painting theory, reforestation, Oceanic ecology and food chains." Just as Japhy predicted, it took Gary forty years to write this monumental series of thirty-nine poems that draw from his journals recording his wandering in rural and urban areas, observations on natural history and philosophy, and spiritual and artistic experiences.

The climax of his reading in Berkeley was his presentation of "The Mountain Spirit." He explained that he had been influenced by a Noh play called *Yamamba* (Old Woman in the Mountain), a fourteenth-century masterpiece by Zenchiku Komparu.

In "The Mountain Spirit," the poet climbs up the White Mountains and hears the voice of a spirit at night. They chant verses to each other. (At the Berkeley reading Gary chanted some lines in a deep Noh-style voice.) Then the spirit and the poet dance the pine tree together: "old arms, old limbs, twisting, twining / scatter cones across the ground / stamp the root-foot DOWN."

Later that year, Stanford University was to host a series of events celebrating *Mountains and Rivers Without End*. Mark Gonnaman, the main organizer of the event, asked me to create a backdrop painting of a bristlecone pine for Gary's reading. A traditional Noh theater in Japan has a simple and austere setting: A painting of an old pine tree occupies the wooden wall in the back, indicating that the stage setting can exist at any time anywhere and allowing the characters in the play to tell where it is they are.

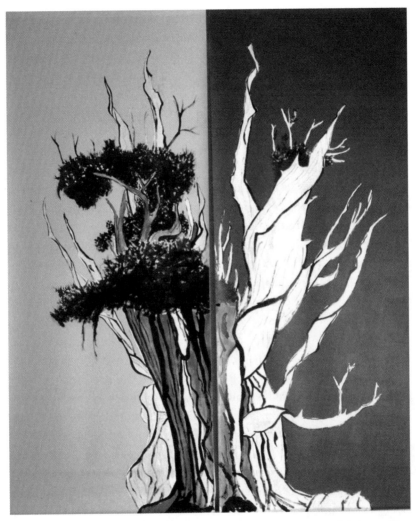

Bristlecone Pine

Gary Snyder represents the best of the prophetic American mind, one that synthesizes wisdom traditions of the world. Known as one of the key poets in the Beat movement of the 1960s, Gary has inspired a great number of intellectuals with his imaginative and meditative vernacular writings, expressing his wild, whole, and ecological thinking.

As a practitioner of Zen and an admirer of Dogen, Gary had created a beautiful, solemn reading on audiocassette of the monk's essays titled *The Teachings of Zen Master Dogen*, which was released by Audio Literature in 1992. The text was selected from *Moon in a Dewdrop*, a book I had previously edited. The epigraph of *Mountains and Rivers Without End* consists of a line from Milarepa and lines from Dogen's fascicle "Painting of a Rice Cake."

I felt honored to have the opportunity to work with him again. Besides, the creation of a backdrop and the painting of a large tree would both be a new experience for me. My idea was to create a painting close to the height of the stage—twelve feet. But a canvas of the size eight by ten feet or ten by twelve feet would be cumbersome to transport or store. So I decided to create a pair of four-by-twelve-foot scrolls. The panels of scrolls would represent the contrasts of day and night, life and death, feminine and masculine.

Taking theatrical effects into consideration, I made a rather stylized small-scale sketch and sent a photocopy of it to Gary for approval. The medieval European masters' technique of using a grid helped the process of transferring the drawn lines of the original sketch to pencil marks on the pair of large canvas panels, which had been stapled on the wooden floor in my studio. I used a housepainter's roller with acrylic paint to create flat skies in the background. I tried to get a watercolor-like effect for the skin-toned bare stems and branches. For the leaves, I used layers of green paint to look like oil paintings. And finally, I drew black contour lines using the decisive techniques of East Asian calligraphy and ink painting.

A wide line in matte black delineated a part of the root of the tree. I used glossy black paint and wrote, "5,000 + 5,000," as an invisible wish for the long life of the tree, and of humanity for ten thousand more years.

We are not separate from these bristlecone pines living at high altitudes. Their longevity has paralleled the course of civilization. And these trees

standing now will watch the future of human society unfold. Their time is our time.

After his reading at Stanford, Gary was speaking with his friends and I went to join them. Gary saw me, pointed to my painting, and said, "A real bristlecone pine looks just like that." I thought it was a kind, upside-down remark.

Where Are We All Going?

It has taken us humans roughly ten millennia to develop our civilization from a tribal agricultural society to a global industrial society. Most cultures have lived with an assumption that humanity will continue tens of thousands of years into the future.

Only in the mid-twentieth century have we begun to perceive the threat of human extinction in the near future. We are now rushing at an alarming pace toward *no possibility* of living ten thousand more years, due to accelerating environmental catastrophes and the spread of ultra-destructive weapons.

We love our children and want them to live long and happy lives. We know that they will want their children to live in the same way. Such a wish for the well-being of future generations has inspired many people over the centuries to take actions that help to preserve society and the environment.

To transmit life and community to coming generations is the utmost responsibility of each generation. Do we not want to fulfill this responsibility? To do so, not with confusion and lack of perspective, but with hope and clarity? However naive or overoptimistic it may appear, don't we want humanity to live ten thousand or more years?

The future of humanity faces enormous threats. It is humbling to acknowledge the incapability of our generation to solve many of our problems. Participation by all segments of society throughout the world is essential to creating a common vision of a ten-millennium future. We need to listen to the voices of as many citizens as possible. We must integrate the views of specialists, leaders, and young people, and take seriously their recommendations to bring about an extended future.

To make a ten-millennium future possible we ought to shift our primary scope of thought and action from short-term corporate and national interest to the goal of long-term global survival; from human-centered society to a truly sustainable society in partnership with the environment. We must make the present time a turning point for this change.

This is the vision of the Ten Millennium Future, a project that I have conceived. The primary process of the project is to ask the public whether we as humanity want to live for another ten thousand years, and find out how to achieve it.

"Where are we all going?" is the title of some of the painting performances I conduct in the name of this project. Here is an example:

In April 1997, I readied myself to do a painting performance at the opening of my exhibition at the Erlangen Museum of Art in Erlangen, southern Germany. The platform that the museum had prepared was about six feet wide and twenty-two feet long. There were five canvas pieces stretched and primed white on the platform.

I asked the audience to imagine that each canvas represented two thousand years. We had ten thousand years ahead of us. And I asked everyone to develop a positive image in their minds of humanity's ability to live for such a long time.

Then I poured paint and drew a continuous line from left to right, up and down across the canvas. This line represented my hope for the transformation of human society—from destruction to revitalization. The first panel's line began red and explosive. In the next panel, the line shifted into blue. And in the following panels, the line became calmer and greener. It was not meant to be proportional to the actual time span. We could not afford to be in the fiery red chaos for two thousand years. If we were to keep exploiting the environment at the current rate, we might cease to exist within a few generations.

In 2000, I created an outdoor performance for the Ditchling Museum in southern England. The village of Ditchling was the birthplace of the Arts and Crafts movement in Europe, which inspired a similar movement in Japan in the early twentieth century. Gandhi also sent a woman here from

India to study the crafts of hand spinning and handweaving for his Swadeshi (domestic handcraft) movement that was part of his nonviolent campaign for India's independence.

I asked Patricia Gidney, an accomplished Ditchling calligrapher, to make niches on a long canvas and put dates underneath—1700, 1800, 1900, 2000, 2100, and 2200.

I explained to the audience that I was going to draw an image of the sustainability of humanity. Sustainability can be defined in many ways. To me it is the potential for humans to live for another ten thousand years. In the past, sustainability was thought to be 100 percent, as people believed the environment would last forever and their offspring would flourish generation after generation. Then in the mid-twentieth century, sustainability started to decline owing to the invention of atom bombs and the nuclear arms race. Now it is declining more so with the destruction of the environment and climate change.

During the Ditchling performance, I took a human-size brush and drew a horizontal green line along the top of the canvas from left to right. Then in between the area of the canvas marked 1900 and 2000, I turned the brush toward the bottom of the canvas. This curve represented the fact that most of us humans are no longer capable of imagining that our species can live for an ultra-long span of time.

I poured some more paint and added a zigzag line, from the end of the downward curve toward the right. My twists represented a series of major social breakthroughs. I then drew a straight line slightly upward, expressing my hope for humanity slowly regaining sustainability.

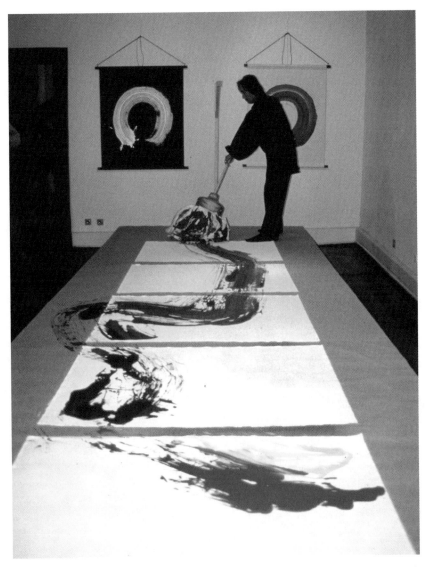

Creating *Where Are We Going?*

Peace Is the Answer

Clear sky, clear as ever.
 Peace is the answer.

Friends over the mountains.
 Peace is the answer.

Medicine in cities and villages.
 Peace is the answer.

All children read books.
 Peace is the answer.

Food for each and every human.
 Peace is the answer.

Beautiful Costa Rica

for Rodrigo Carazo

In the light mist of a cloud forest
a tiny, tiny blue bird speaks to us:
 You are beautiful.
 You are wise.
 You are strong.
 Look at me.
 Listen to me.
 Follow me.
 Follow me all the way.

In the dense green of a rainforest
a giant, giant butterfly speaks to us:
 You are beautiful.
 You are wise.
 You are strong.
 Look at me.
 Listen to me.
 Follow me.
 Follow me all the way.

In the beautiful country of Costa Rica with no army
a happy, happy friend speaks to us:
 You are beautiful.
 You are wise.

You are strong.
Look at us.
Listen to us.
Follow us.
Follow us all the way.

In 2009, I met Rodrigo Carazo, the president of Costa Rica from 1978 to 1982. He and his colleagues invited me to come to Costa Rica to do some peace work with them. Knowing that their country had abolished its military forces in 1948, I proposed that we start an international citizens' organization, A World Without Armies. And I asked President Carazo to be the honorary founder of the organization.

How Realistic Is a World without War?

"**G**reat peace" is a vision of the world with no more war or systematic violence. Will it ever be possible? To explore if it is, first I would like to examine with you the huge array of challenges we face to see how we are forced to be pessimistic. Then I will examine ways to meet the challenges and see if there is even a slim chance for anyone to be optimistic about the potential of a world without war.

There is a common belief that basic human nature is violent. The fact that in early human history a majority of male members of tribes and kingdoms participated in hunting, fishing, and fighting appears to support this notion. When military institutions developed, the glorification of self-sacrificial actions of war, conquest, and victory became so prevalent that it was attractive to boys to become members of combat forces. Boys or men also were often forced to join military forces, and were put to death if they refused. Offensive campaigns were waged for expanding territory, or defense of tribes or nations, which was often the most pressing aspect of security for the social order, as well as economic expansion. Throughout human history it has been rare to have centuries or even decades without war in most geographic regions.

Societal problems we see in today's world include dictatorship, totalitarian regimes, corruption, injustice, lack of freedom, rotten electoral systems, discrimination, inequality, poverty, human rights abuse, scarcity of resources, destruction of the environment, religious persecution, foreign occupation, excessive influence of powerful nations, and border disputes.

One measure for discerning the degree of democracy of a nation is to evaluate its freedom of the press. According to a global rating from the Freedom House report "Freedom of Press 2016," thirty-two nations have freedom, sixty-two have partial freedom, and sixty-six are not free.

Naturally, many of those who are oppressed and those who are concerned about widespread oppression and censorship are determined to eliminate or reduce such problems. In contrast, some political leaders are determined to make their nations, ethnicities, or religous communities more powerful, expansive, and dominant. On either side, people may first try to achieve their goals by negotiation and diplomacy. When their peaceful endeavor fails, however, they tend to resort to violence—coup d'état, ethnic cleansing, or war, accompanied by kidnapping, torture, rape, confiscation of property, relocation, burning, and massacre. Thus, where there are serious social problems with no possibility seen for peaceful resolution, there is the potential for systematic violence or armed uprisings in response to the problems.

Nowadays, it doesn't take a nation to start a war. A small number of terrorists can recruit fighters on the Internet and cause tremendous damage by suicide bombing and mass shooting. In the near future, terrorists may get hold of chemical weapons or radioactive substances. Cyber hackers may acquire the capacity to penetrate the otherwise tight security systems of nations and industries in order to cripple targeted factories, sabotage power or water supplies, or even set off bombs.

Those who find their self-identity in opposition to others promote their ethnic, cultural, religous, gender, or ideological supremacy. If in power, they build up their control over the general public through education, propaganda, and brainwashing, while often hiding disturbing scenes of bloodshed, imprisonment, and the reality of the sufferings of many people. They try to shape a common mentality in the society to the point where a great many members are fanatically ready to arm, fight, and die, with the utmost sense of honor. The public often thinks of resolving a conflict by simplistically asking, "Shall we, or shall we not strike?"

The sole purpose of weapons is to injure or kill others. Weapons don't produce food, medicine, or any life-affirming or environmentally sustaining materials. The military forces of nations consume a disproportionate amount of energy. Firing weapons and setting off bombs in testing weapons, and in actual combat, create explosions, fire, and smoke, pollute lands, seas, and air, as well as cities and villages, not to mention destroying human lives. Maintaining combat forces and the infrastructure to support them requires an

astronomical amount of energy. For example, the US Department of Defense, as the largest single consumer of energy in the world, is responsible for 80 percent of the federal government's total energy consumption; the amount that could power more than twenty-four million households for a year. (An average US household uses about 10,000 kilowatt-hours of electricity each year.) And, aircraft, vessels, and vehicles for fighting are not designed to conserve energy. Armored vehicles, for instance, get between 0.6 and 2 miles per gallon. The B-52 bomber consumes about 3,300 gallons of fuel per hour.

The weapons and defense-related industries, such as those involved in the construction of military bases and related infrastructure in countries with advanced technology, are supported by policy makers. In contrast, those who are against the war machine or want to place restrictions on the defense industry are often branded as unpatriotic. As the military-industrial complex has an extremely close and intricate relationship with government officials, the nation's defense budget keeps expanding with no one being able to stop it. This mutually reinforcing system can be seen as a "gross self-interest complex." Members of the defense industries and governments, including congresses or parliaments, are tightly protecting their mutual interests. Therefore it is extremely difficult to cut off their ties and shared benefits.

By the end of the Cold War, the superpowers had acquired the capacity to flatten the surface of the earth and eliminate the human race multiple times. Since the end of the Cold War, there is no justification for making hydrogen bombs more powerful, as such devices that destroy the environment affect all people, including those who would deploy them. Yet, all states that possess nuclear weapons spend a huge amount of money just to continue the business of feeding the arms industry and related profiteers.

Nations that export weapons make an enormous amount of money. Similarly, politicians of weapons-importing countries profit legally or—in most cases—illegally. War-torn regions are saturated with small, medium, and heavy weapons.

Global annual military spending was $1.76 trillion in 2014, according to the Stockholm International Peace Research Institute, with the United States being responsible for one-third of that amount. In the meantime, global funds urgently needed to address climate change will be $100 billion

per year for the next twenty years, a target set by Green Climate Fund of the United Nations Framework Convention on Climate Change. Funds needed to save the earth are less than one-fifth of global annual military spending. This clearly illustrates how disproportionate the military spending of the world is.

Violence is most commonly responded to by violence. Victors humiliate losers and the losers vow to take revenge; thus, the vicious cycle tends to continue. Children who suffer at an early age from the abuse and deprivation caused by war, social injustice, poverty, and gang-related and domestic violence have a hard time recovering from the trauma. Later, they themselves can turn out to be perpetrators of violence. Thus, the misery of the effects of violence seems to be hard to end, and the seeds of war keep growing, while the news media is full of reports on war, terrorism, and violence, and the entertainment industry mirrors and stimulates the world of fighting. This is the reality of the current world; thus reasons for pessimism are overwhelming and provide an invitation to cynicism: "The problems are so complex and huge. No one can change the situation, so I won't do anything."

Instead, how can we be positive? Scientific research shows that humans respond to a very brief exposure to happy and angry faces with smile and frown muscle activity, respectively ("Unconscious Facial Reactions to Emotional Facial Expressions," U. Dimberg, M. Thunberg, and K. Elmehed, 2000). This shows that we all have a basic capacity for sympathy, which is the basis for angry or compassionate actions.

Canadian psychiatrist Jaswant Guzder and her international team have been working in Jamaica, a country known for having the highest murder rate in the world. They picked thirty students ages eight to nine in an inner-city school who had poor academic performance and behavioral problems. For two and a half years, they assisted teachers in offering academic tutoring and cultural activities such as storytelling, poetry, music, dance, and theater along with mental health programs. The result was a remarkable improvement in academic skills, capacity for trust and social reciprocity with peers and teachers, as well as an increase in resilience and a reduction of internalizing and externalizing behaviors ("Promoting Resilience in High-Risk Children in Jamaica," J. Guzder, V. Paisley, H.

Robertson-Hickling, and F. W. Hickling, 2013). Now they are instituting this program in scores of schools all over Jamaica.

From these findings we may be able to say that basic human nature is sympathetic, kind, and creative, and children become either kind or cruel according to how adults treat them and what education they receive. Parents or family members raising children and educators teaching them to be peace-loving are most fundamental for creating a peaceful society.

How do we build a society that is committed to the peaceful solution of domestic and international conflicts? In order to do so, we citizens need to have full knowledge of a potential military conflict: who the "enemies" are, what the chance of war is, and what the consequences may be—in human lives, in money spent, in environmental destruction, and in long-term social impact. We should also know the option of a peaceful solution and its con-sequences as an alternative. Peace studies should include a comparison of expenses for war with the potential distribution of such funds for the welfare of citizens domestically and worldwide.

Much of the world's war effort today is focused on counterterrorism tac-tics: regional wars, targeted killing, drone attacks, airport checks, and other reactive military and security efforts. With no doubt, this is necessary, as some terrorists are waging war on Western countries, and we need to de-fend ourselves. Islamic extremist organizations are like a developed cancer, where aggressive and invasive treatments are the only effective means to cure or reduce the symptoms. At the same time, however, we need to have deep understanding of the historical, social, and cultural causes, as well as the psy-chology and theology of terrorism. Members and supporters of these orga-nizations are in general dissatisfied, unhappy, and violent. Why? And how do we help to change situations that directly affect them, and guide them to peaceful thinking and behavior?

It's likely that no one knows at this moment how to deal with such issues. But this does not mean that there is no solution to end terrorism other than military and police actions. We need experts in many fields from all sides, as well as policy makers, to form something like nonviolence think tanks. The solutions may include offering food, clean water, medicine, clinicians, social workers, and schools for the overall reduction of poverty, and extend-

ing friendship instead of providing weapons or dropping bombs. Helping people who are poor and oppressed to raise their living standard, as well as commencing dialogue among all parties, can enhance the potential of reducing destructive behavior. I believe that if we spend 1 percent of the projected cost for war against the extremists, we will come up with a concrete set of solutions. And, perhaps, if we were to direct 10 percent of the projected war expenses toward peaceful aid, it might be possible to contain terrorism.

Japanese troops inflicted massive atrocities all over China, South and Southeast Asia, and the Pacific between 1937 and 1945. I personally witnessed its final period as a young boy: the hysteria of Japanese imperialism, militarism, and colonialism, as well as a collective suicidal mentality. There were plenty of young men who would proudly conduct kamikaze (divine wind) suicide air attacks against US forces in 1945 when Japan was losing battles in the Pacific. After its unconditional surrender, Japan decided to be a peaceful nation and put a great deal of effort into peace education. No Japanese today, except for a few right-wing radicals, even think of resolving international conflicts with military force. The Self-Defense Forces of Japan have shot not even one bullet against an enemy since its founding in 1950. This historical transformation in Japan gives me hope that many fanatic Islamic youngsters who are volunteering to conduct suicide bombings and massive attacks can become peaceful citizens. How? The answers ought to be obtained by deep and extensive studies of terrorism and its "holy war" theology, and a search for solutions.

Throughout history until the end of World War II, Europe had been contaminated with wars. Nazi Germany's invasion of almost all of Europe and much of North Africa, with its massacre of millions of innocent people, was the most horrific of all. But a little over a decade after World War II, a large no-war region came into existence in Europe. Beginning with five founding member states in 1957, and originally known as the European Economic Community, it developed into the European Union in 1992. Now it consists of twenty-seven nations. The original idea was that citizens of one member state can live and work in any of the other member states, with the result that citizens of a nation need not be concerned with having to defend themselves from any other member state. And, the European Union is so huge

that no nonmember state would dare to invade one of the member states. For the first time in history, many nations are free of armed conflicts among themselves.

Unfortunately, in recent years because of the financial crisis of Greece and elsewhere, as well as a large-scale flow of refugees from war-torn neighboring countries, including Syria, some nations are building fences, and the practice of having no borders is facing a great challenge. The Brexit represents new challenges for the European Union. The original objectives, however, and the initial success and expansion of the European Union for over two decades demonstrate that a large number of nations with diverse cultures, languages, and history can live peacefully together as one international body. If blocs of nations in other regions follow this example and try to form a Central American Union or North African Union, the world will be a much safer and happier place. Citizens of nations in other regions should study how Western European peoples, including such former sworn enemies as the French and Germans, developed trust with each other. Something as simple as a winemakers' exchange is a good example of common people's effort for building a larger community. A great majority of the world should follow the remarkable example that the European Union provides.

Ethnic cleansing intends the establishment of ethnically homogeneous regions or nations by the forcible displacement or genocide of people in that region belonging to certain other ethnic groups. The United Nations international tribunals prosecuted leaders of the former Yugoslavia and Rwanda for violations of international humanitarian law in the 1990s. Since then, those who want to commit such a crime would have to think twice if they dare to risk being tried and punished as war criminals. Hopefully, such a brutal practice will die out.

A notable role of the military in history has been to engage in a coup d'état—a sudden and violent takeover of a government by one or more members of the armed forces. These people already possess and are highly trained in using weapons. So when a leader or leaders of such an institution see corruption, incompetence, or weakness in an administration, there is a temptation for them to give orders to take over the government. But military people are trained to fight, not to govern. That's why military regimes tend

to be incompetent, oppressive, and corrupt. There is no lack of such failures in history.

Coups were a regular occurrence in various Latin American nations in the nineteenth and twentieth centuries, and in Africa after the countries there gained independence in the 1960s. Even recently, between 1952 and 2000, thirty-three countries experienced eighty-five such depositions, with West Africa having the most (forty-two), largely against civil regimes. Twenty-seven of these coups were against military regimes, and in five, the deposed incumbents were killed. There are some cases where the military institutions overthrew tyrannical monarchs or dictators and established democratic regimes. But there are more cases where the military disrupted democratic regimes and established dictatorships. Also, taking away from people the right to participate in the political decision-making process is a human rights abuse. Thus, I humbly suggest that those who plan and execute a coup d'état in a democratic country should be viewed as war criminals according to the international statute, and be tried at the World Court.

The antidote to a coup d'état is civilian control that places ultimate responsibility for a country's strategic decision making in the hands of the civilian political leadership, rather than with professional military officers. Since the time of its founding, the United States has provided exemplary practices of civilian control. All democratic nations should do their best to establish this system and train soldiers to avoid any military takeover and keep a stable and liberal democracy.

News about war and violence is more captivating to the public than news about nonviolent social changes. So, people tend to get the impression that violent resistance is more prevalent than nonviolent resistance. Therefore we need to learn about the effectiveness and wide-ranging achievement of nonviolent social change. The successes of the nonviolent movements led by Gandhi, Martin Luther King Jr., and Nelson Mandela, prevailing against gross and seemingly impossible-to-change regimes of tight control, discrimination, oppression, exploitation, and violence, have inspired many of those engaged in civil resistance.

Nonviolent action is a practical and effective method that replaces reliance on violence. Nonviolent resistance requires a great deal of thinking,

study, and strategy building. One of the most influential theorists in this field is the US political scientist Gene Sharp. In 1973, he published *The Politics of Nonviolent Action*. It represented both a quantitative and qualitative leap forward worldwide in the spread of knowledge about nonviolent struggle. This is where his famous 198 nonviolent methods first appeared. Another book of his, *From Dictatorship to Democracy*, first published in Thailand in 1993, has been studied and utilized by a great number of activists worldwide. "Why Civil Resistance Works: The Strategic Logic of Nonviolent Conflict," a paper by Maria J. Stephan and Erica Chenoweth, summarizes well the heart of the issue on the effectiveness of nonviolent campaigns: working with their data set of all known major nonviolent and violent resistance campaigns from 1900 to 2006, their findings show that major nonviolent campaigns have achieved success 53 percent of the time, compared with 26 percent for violent resistance campaigns.

According to Stephan and Chenoweth, the reason for the greater success of nonviolent resistance is that a campaign's commitment to nonviolent methods enhances its domestic and international legitimacy and encourages more broad-based participation in the resistance, which translates into increased pressure being brought to bear on the target. Recognition of the challenge group's grievances can translate into greater internal and external support for that group and alienation of the target regime, which undermines the regime's main sources of political, economic, and even military power. Also, regime violence against nonviolent movements is more likely to backfire against the regime. A sympathetic public perceives nonviolent resistance groups as less extreme, thereby enhancing their appeal and facilitating the extraction of concessions through bargaining.

However, some nonviolent campaigns fail, and even if they do succeed, there can be huge setbacks that can result in them being overtaken by a military or nondemocratic regime. Each situation is different. Therefore, again, we urgently need "nonviolent think tanks" that provide strategic advice and resources for the success of social changes.

International peacekeeping forces need to be well set up to respond to aggression by states or nonstate entities. Nations need military forces when they get threats of foreign invasion or civil war. On the other hand, nations

without such threats, such as member states of the European Union, New Zealand, Australia, and Switzerland, don't need their own military forces, except for police and border control. Disaster rescue can be conducted by civilian organizations. Even so, most nations want to keep military forces, possibly due to a long-held habit or addiction. They want the military for jobs and related business.

Global demilitarization would and will be a slow process. A condition for a country to demilitarize is, above all, a regional security where no nation invades any other. A domestic security system is also needed to eliminate the potential of armed uprising. The government must be functional and without a history of systematic corruption. To make demilitarization possible, there should be solid civilian control while every effort is made to keep soldiers well paid, trained, and disciplined. (It's ironic that we need good military forces so that they can be abolished.) To determine if a country is ready for a discussion on demilitarization, there needs to be solid academic research on its demilitarization potential.

A World Without Armies, the international citizens' organization I created in 2000 with Rodrigo Carazo, former president of Costa Rica, has come up with a plan called Prosperous Conversion Formula: Some soldiers may love to give up arms and enjoy the same amount of salary and benefits. They may be retrained to perform civilian work that they can continue to do until they have reached an older age than would have been possible in the military. If this plan is carried out and about 5 percent of military personnel are converted per year, there may be no radical reduction of security or of the perception of lack of security within a nation. This is especially true if the reduction of military forces is done simultaneously with neighboring nations. Then, demilitarization may not create anxiety among either the citizens or leadership. Commanders who initiate and oversee disarmament and abolition should receive the highest honors—much more so than winning battles. Political leaders and activists should also be remembered as pioneers of an enlightened society.

Already, one continent is demilitarized: Antarctica, under international agreement. More than 11 percent of the member states of the United Nations are without military forces. They are Andorra, Dominica, Grenada, Haiti,

Iceland, Kiribati, Costa Rica, Liechtenstein, Marshall Islands, Mauritius, Micronesia, Monaco, Nauru, Palau, Panama, Vatican City, St. Kitts and Nevis, St. Lucia, St. Vincent and the Grenadines, Samoa, San Marino, Solomon Islands, Tuvalu, and Vanuatu. The next step would be having a few more midsized nations join the club until the United Nations establishes a Council of Demilitarized Nations.

Nations that export weapons want other nations to maintain or expand their fighting capacities. Most of these nations want to contribute to world peace, and yet they and their corporations make a profit on selling weapons that are causes of fighting and destruction. I often hear friends say, "Our country exports weapons." But I almost never hear them say, "We are trying to stop our country from manufacturing or exporting weapons." We need to understand, however, that where there are no weapons, there is no temptation to use them.

A disproportionately large military budget was the main cause of the collapse of the Soviet Union. The record-high war expenses of the Afghanistan and Iraq wars, along with other financial failures, laid the ground for the United States and the rest of the world for the Great Recession of 2008.

By reducing spending on the military-industrial complex, nations can do a great amount of work for the well-being of citizens and the protection of the environment. This is a simple fact. Costa Rica has been demilitarized since 1948, which made possible the maintenance of universal free health care and education, and its worldwide leadership in environmental protection and the happiness of its citizens. Panama, which was demilitarized in 1994, is leading Latin America by its rapid economic growth and has recently been rated the number one happiest nation, according to the 2014 Gallup report.

Many peoples in the world have learned that democracy is a better governmental system than dictatorship, totalitarianism, or other military-ruled systems. Some reasons for this include the following: democracy helps to prevent rule by cruel and vicious autocrats; democracies go to war with each other less often; and democracy tends to foster human development, as measured by health, education, personal income, and other indicators.

The only way to reduce the destructive influence of the military-industrial complex is to reform nations' electoral systems step by step and

establish genuine democracies. The full meaning of democracy is that, without restrictions, all citizens can participate in the process of electing officials and lawmakers, and public opinion is adequately reflected in political decision making without the influence of money. In order to have this implemented, all branches of the government need to be clean and fair, and the electoral process should be free of fraud and corruption. When the citizens' will is fairly reflected, I believe nuclear weapons will be abolished and weapons production and military spending will be radically reduced.

A mature human being is kind, thoughtful, fair, and nonviolent. A mature human being regards other people's interests as being as important as his or her own. A mature human being regards the future as being as important as the past and present. A mature human being regards the environment as important as human interests.

A mature society is also kind, thoughtful, fair, and nonviolent. By participating in and developing a mature society, we reduce the potential of systematic violence and war. Do you agree to this?

It's not that the mightiest and richest country with the most advanced technology is the greatest nation on earth. Rather, I myself believe that nations committed to nonviolent solutions to domestic and international conflict, and achieving a high rate of happiness for its citizens, should be regarded as the greatest.

It's all up to you to make a world without war realistic or unrealistic. Great peace is in your hands. None of us humans alive now may see a world in great peace. However, we can envision great peace and participate in the process of actualizing it. Each one of us can be a great peace worker, enjoying a chance to be a humble part of the great work of peace.

From One Candle

In the darkness of war and violence
spread the light of a peaceful way.
From one candle to another,
and to another—to many more . . .

In the darkness of wrath and hatred
spread the light of loving-kindness.
From one candle to another,
and to another—to many more . . .

In the darkness of smoke and sorrow
spread the dream of an end to war.
From one candle to another,
and to another—to many more . . .

From one candle to another,
and to another—to many more . . .

VIDEO AND AUDIO SOURCES

Painting Peace: Art and Life of Kazuaki Tanahashi.
Film by Babeth Van Loo. 2014. 90 minutes.
Streaming: www.buddhistfilmchannel.com; DVD and Blueray:
http://zenbrush.net/

Reflection and Remorse: Sino-Japanese War.
Film by JR Sheetz. 2008. 6 minutes.
Link: www.aworldwithoutarmies.org/films.

Dear Los Alamos Worker.
Film by Martijn Robert. 2015. 7 minutes.
Link: www.aworldwithoutarmies.org/films.

*Imagining Peace: Peace Poems by Kazuaki Tanahashi, set to music
and performed by West Coast composers.*
Produced by Judith-Kate Friedman. 2003. 15 songs.
CD: http://zenbrush.net/

ABOUT THE AUTHOR

K azuaki Tanahashi, artist, Buddhist scholar, and peace worker, was born in
Japan in 1933. He moved to the United States to be a scholar in residence
at the San Francisco Zen Center in 1977. Soon he joined a massive movement
to reverse the nuclear arms race. While translating Zen master Dogen's writ-
ings, he developed the genre of one-stroke painting, as well as multicolor Zen
circles and East Asian calligraphy, exhibiting worldwide. He has served as
secretary of Plutonium Free Future, director of the Ten Millennium Future
Project, and currently is founding director of A World Without Armies. He
is a Fellow of the World Academy of Art and Science. For more information
visit his website at: www.brushmind.net.